GOOD TIMES

AT HOME AND ABROAD BETWEEN
THE WARS

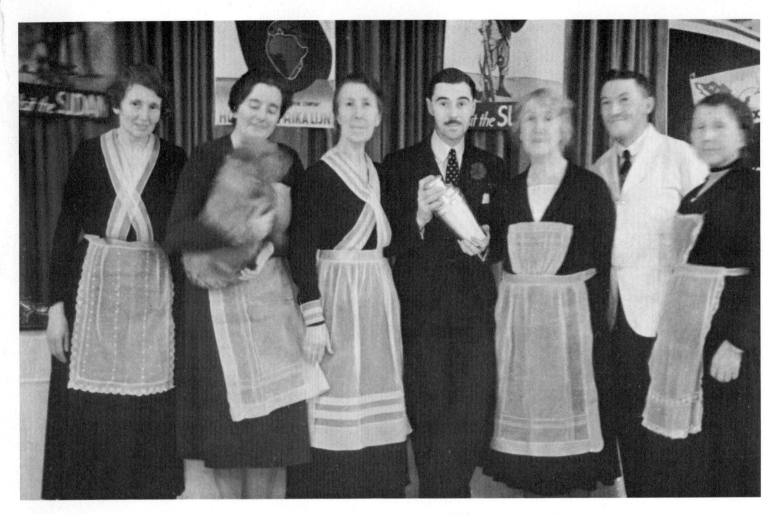

A cocktail party at my parents' home in 1932 to celebrate the publication of my first travel book, *With a Passport and Two Eyes*. The walls were appropriately hung with travel posters cajoled out of Thomas Cook by 'Nan', on my right.

V. C. Buckley

Good Times

At Home and Abroad between the Wars

With 197 illustrations

Thames and Hudson

Printed and bound in the United Kingdom by William Clowes & Sons, Limited, Beccles, Suffolk.

Contents

TO MILDRED JAFFE

Foreword

MANY PEOPLE have told me that they seldom bother to read the foreword of a book. This seems a pity, for it is here that the author endeavours to say 'How do you do' to his readers and to give some explanation of what to expect in the following pages.

However, if the majority really do not read forewords, perhaps this time they will imagine that they are listening to a voice speaking from some radio station:

'Good evening, everybody. Here is a book of photographs, every one taken by myself or with my own camera from 1909 to 1939—thirty years of great change, a period covering a tranquil and elegant way of life during the disillusioned but fun-loving 'twenties and 'thirties.

'Many times, in changing homes, I have been tempted to destroy my hundreds of carefully documented negatives, but somehow I have always resisted—hence this very personal collection of places, people and events up to the outbreak of World War II on 3 September 1939.'

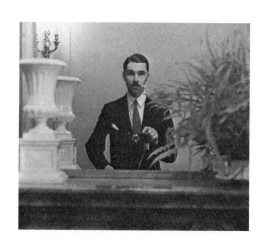

Schooldays

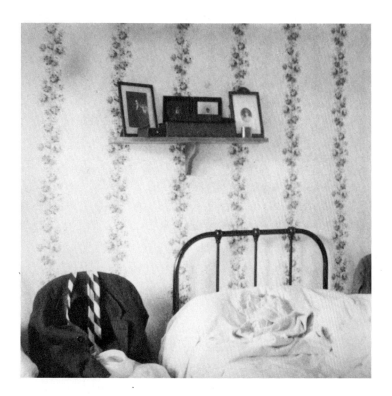

My dormitory at the school in Hertfordshire where I was an exceedingly homesick boarder from 1910 to 1914. It was there that I took my first interior photographs (time exposures) and won my first prize—not for work but for sport.

ON ARMISTICE DAY I was a 17-year-old boy at Eton and I can remember most distinctly the events that began at 11 a.m. on 11th November 1918. I was at that hour in a classroom facing the Chapel built in 1441 by Henry VI. The whisper went round the room that there would be no more work that day. As the great clock in School Yard struck the hour, someone shouted 'the war is over', and we were told that the class was dismissed. I rushed back to my room to collect my camera, but after a frantic search remembered I had lent it to a friend in another house. It is probably the only time in my life that I was without my camera on an important occasion.

I then joined several hundred yelling boys rushing up to Windsor where military bands were playing and lorry-loads of soldiers stationed in Windsor were waving their caps and singing 'Tipperary' and 'There's a Long Long Trail'.

On Castle Hill, near the statue of Queen Victoria, the two old Miss Camerons, who kept a sweet shop, were handing out strictly rationed wartime chocolates to the crowd.

On returning across the bridge into Eton High Street I was met by another mob of boys, top hats on the back of their heads, shouting, blowing whistles, waving flags and some even beating tin hipbaths they had dragged from their rooms.

Wanting desperately to share all this jubilation with my parents, I ran into the small post office in Eton and asked if they could possibly put me through to our London telephone number, Victoria 1500. My mother answered the phone—'Darling, wonderful to hear your voice, what a memorable day, no more killing and now you will be safe, God bless us all'—and then I heard loud sobs before we were cut off.

It was a day I have never forgotten; a day on which a new era began.

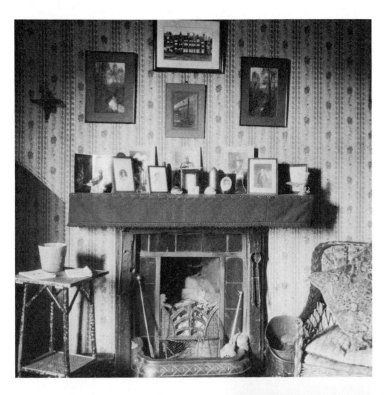

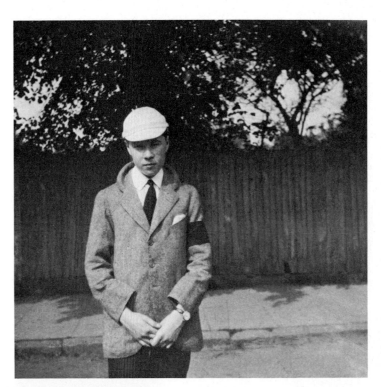

The bedroom-cum-study at Eton which I occupied from 1914 to 1919. The bed folded up during the day; the only heating was a small coal fire; there was no running water and only two bathrooms for the forty boys in our house.

School Yard, Eton, on the Fourth of June, Founders Day. 'Absence' (a roll-call) is held here twice a day on holidays, as well as on half-holidays during the summer months to prevent boys from going out of bounds (i.e., up to London). In the summer of 1914, just before I went to Eton, two boys from my house were expelled for going to London without permission. They went to a theatre and had the very bad luck to sit next to an Eton master who recognized them.

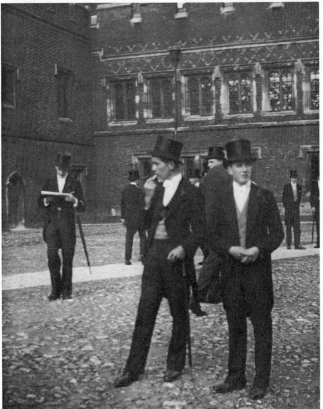

Myself in what is called 'half-change' at Eton. Full change was for all sports; everyday school wear was top hat, tails, striped trousers and white shirt and bow tie. Collars had to be turned up unless one was in the Sixth Form. The black armband was customary if a parent or grandparent had died.

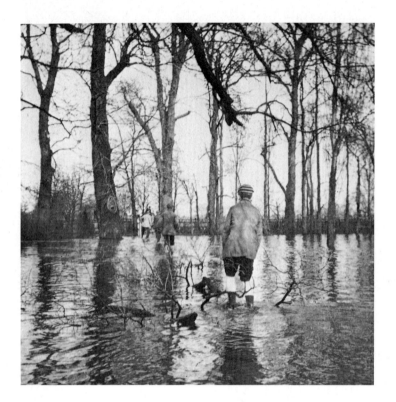 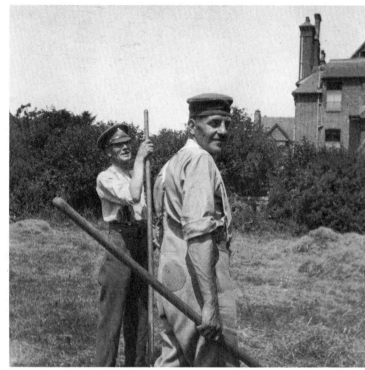

In February 1917 the Thames flooded its banks and inundated the low-lying streets of Windsor and Eton. Many of the College playing-fields were under water.

A German prisoner-of-war in 1916, with a British soldier escort, helps with haymaking on one of the playing fields of Eton.

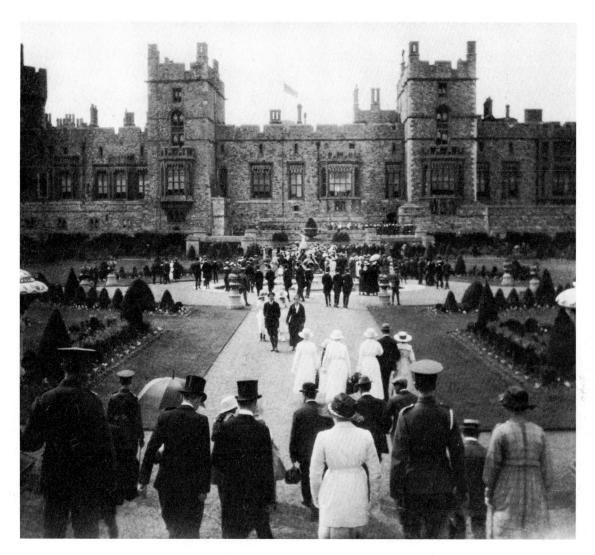

On the west terrace of Windsor Castle a military band used to play for two hours on summer Sundays. The terrace was open and I remember often seeing Queen Mary and King George V watching the crowds through a castle window.

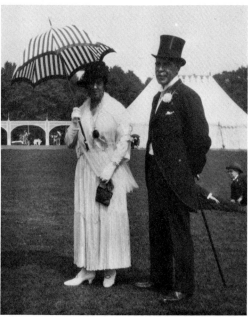

My mother and father in 1919 at Lords Cricket Ground, London, for the first Eton and Harrow match to be held there after the war.

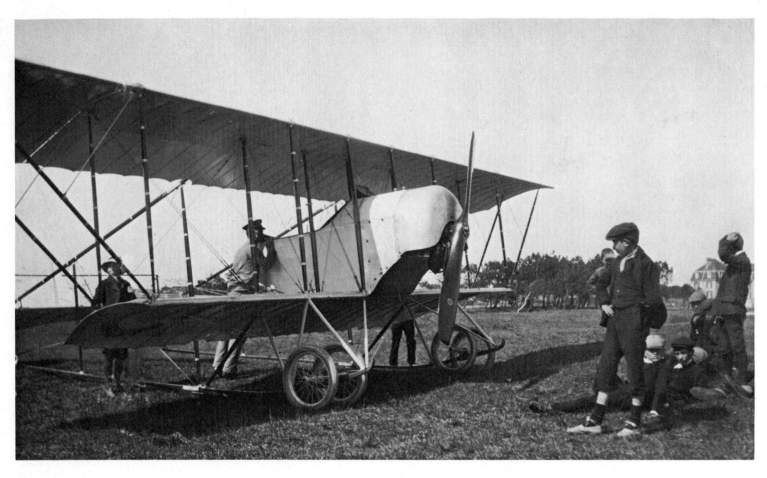

M. Caudron's personal biplane made a forced landing on the
golf-course at Le Touquet in the spring of 1914. The Caudron
biplane soon became a famous French war-plane.

In 1917 a military Avro biplane made a forced landing on one ▷
of the playing-fields of Eton. It naturally caused great
excitement, as few of the boys had ever seen an airplane at
close quarters.

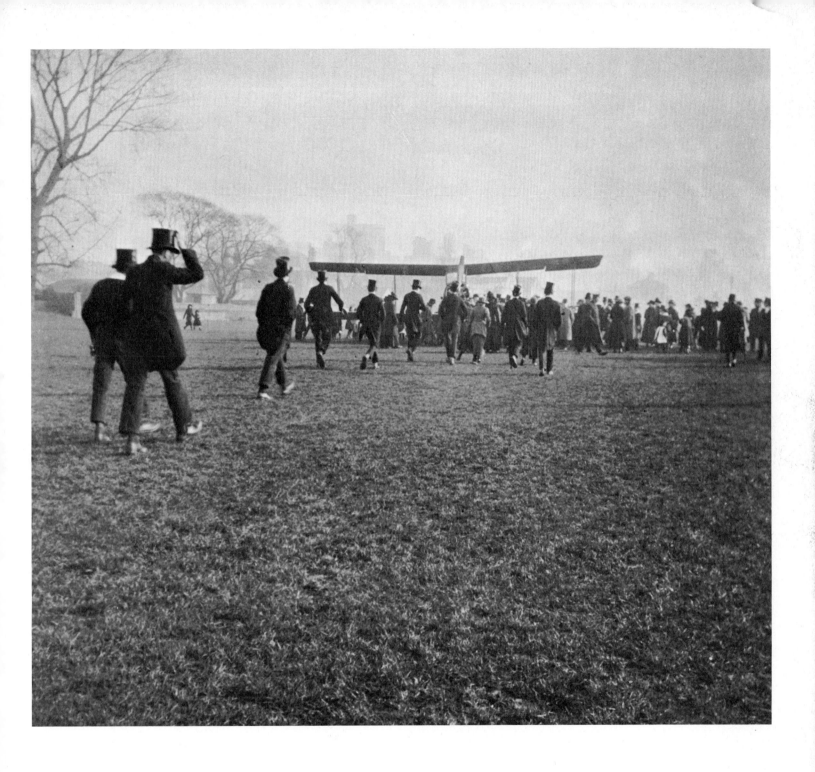

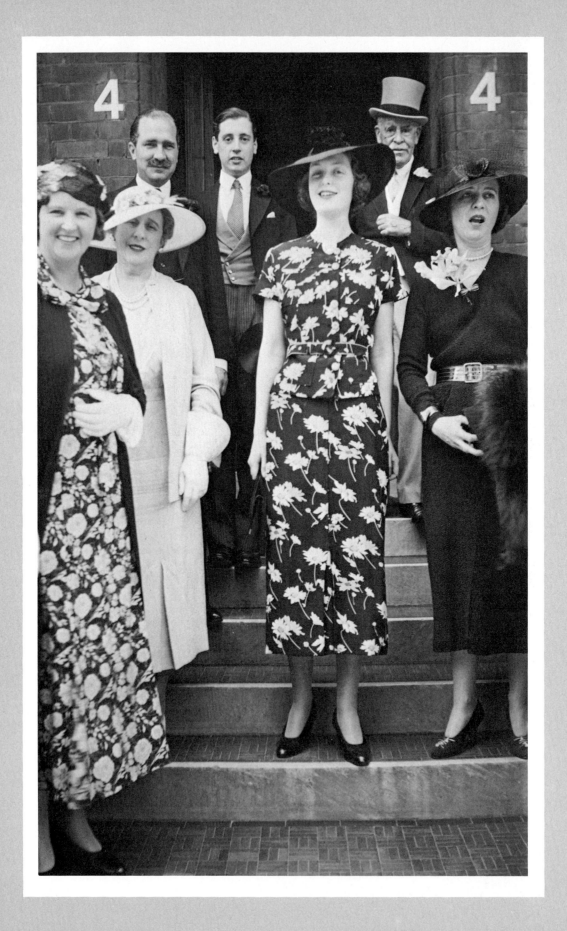

London

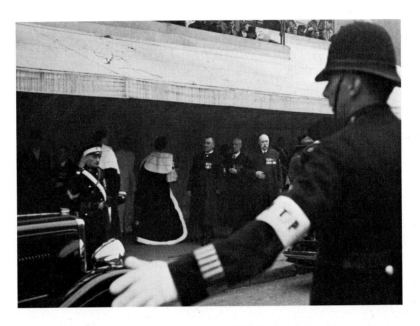

'The Long Arm of the Law' outside Westminster Abbey at
the 1937 Coronation of King George VI.

◁ Guests posing for my camera on their way to a wedding.

IN 1918, at the end of what was then called the Great War, it was as if, after four years of food shortages, Zeppelin raids, and the appalling casualties at the front, London took a deep breath and plunged desperately into a new era.

Women took jobs in offices, were given the Vote, bobbed their hair and wore short skirts. Chaperons suddenly became out of date. Life was less formal and moved much faster. Horse-drawn buses and cabs gradually vanished, and motor buses, taxis and ever increasing numbers of private cars appeared. At Croydon Aerodrome, airplanes took off from grass runways for passenger flights to Paris and other European capitals.

In the 1920s the hunger marches made one aware of the urgent social problems, and of the melancholy fact that a 'land fit for heroes to live in' simply did not exist. I noticed, with youthful sadness, the legions of legless and armless bemedalled ex-servicemen standing at street corners playing music-hall tunes on trumpets and penny whistles. Like the ex-army major whose gymnasium I frequented, they also had returned home to find few jobs available.

London went dancing mad. There were tea-time dances, elaborate charity balls held at West End hotels with large resident dance bands, seedy clubs in back streets and vast palais-de-dance halls in the suburbs: millions were foxtrotting to the new rhythm, Jazz.

In May 1926, after seven years of mass unemployment, came the General Strike. In glorious weather, enthusiastic young men and women drove trains and buses and distributed the 'British Gazette', a Government newspaper, printed at the offices of the *Morning Post* in Fleet Street. The whole country was run by amateurs and the armed forces. There was practically no violence.

I remember one evening driving American friends round London. As we passed some riverside derelict warehouses, near where Sir Christopher Wren had lived while building St Paul's, they asked, 'Is it really safe here at night?' I remember replying: 'Of course it's safe, this is London.'

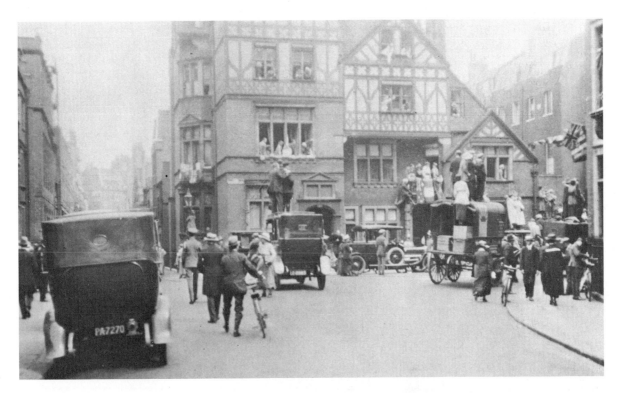

The windows of my parents' house in Hans Crescent are open to allow the family, staff and friends a glimpse of a Victory parade passing along Sloane Street in July 1919. A taxi (centre of the photograph) is standing on the old horse-cab rank.

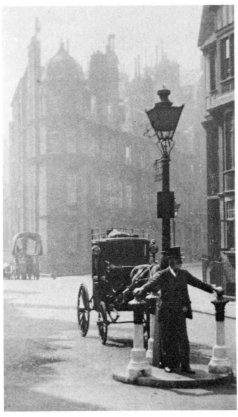

A four-wheeler cab and its driver waiting on the small cab rank (still there) at the corner of Hans Crescent and Sloane Street (1911). It was one of the very first photographs taken with my Brownie camera. Until about 1920, if a cab was required by one of the big houses, a butler, parlourmaid or the owner would stand on the doorstep and blow a cab-whistle.

Two men in full regalia on their way to attend one of the King's Levees.

A member of the Royal Household leaving his home in Egerton Gardens in pouring rain to attend a function at Buckingham Palace. The picture was taken through my parents' dining-room window.

Albany, an 18th-century London oasis near Piccadilly Circus. It is a collection of apartments that resemble Oxford/Cambridge college living quarters; there are stone stairs, long stone corridors, massive front doors, but elegant large rooms. Uniformed porters guard its entrance. Among its many famous tenants have been Lord Byron, Mr Edward Heath, the novelist Graham Greene, the actress Edith Evans.

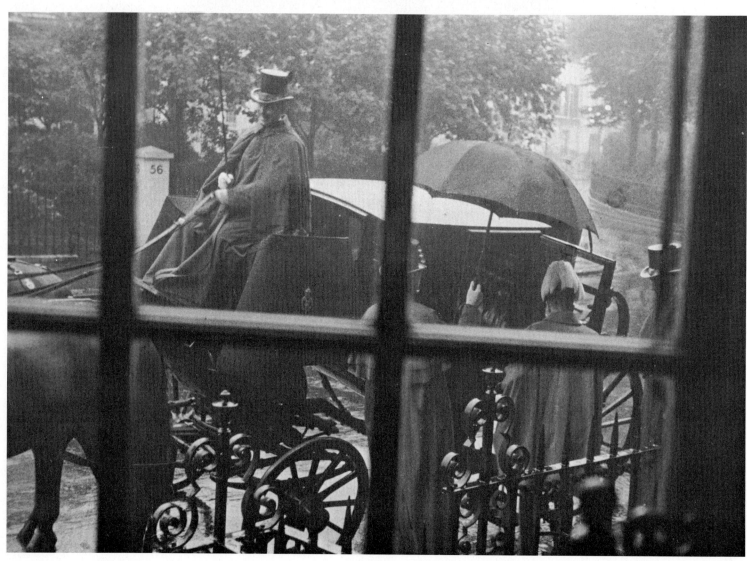

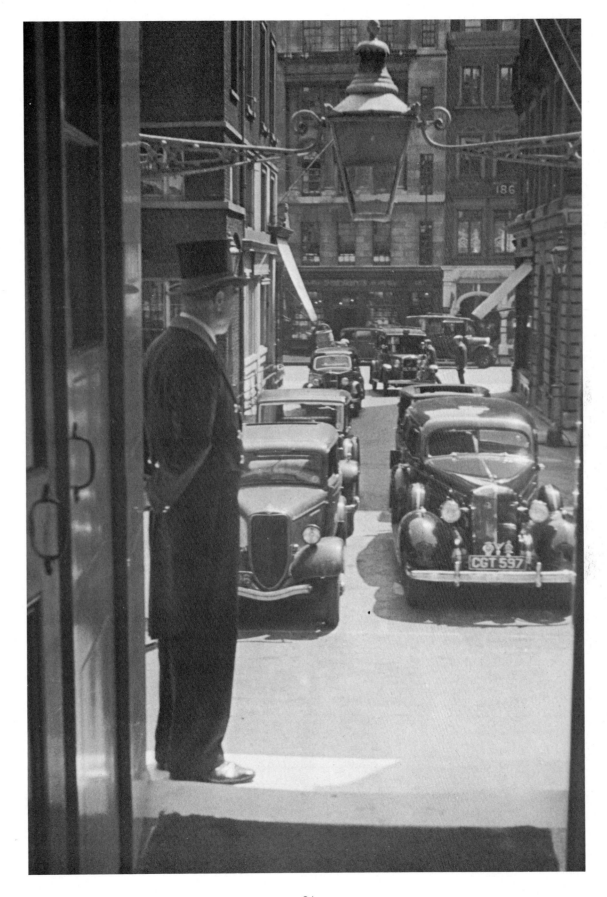

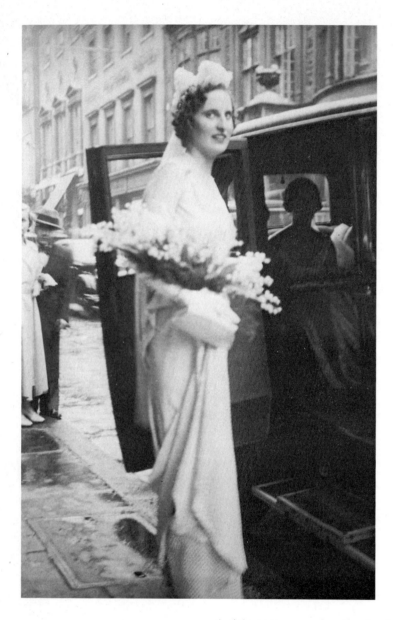

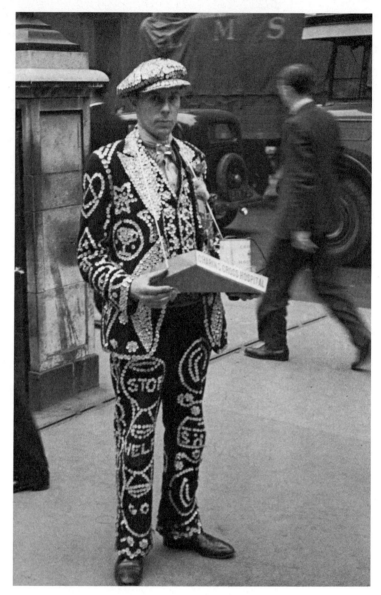

A debutante, wearing the traditional three white feathers, on her way to Buckingham Palace to be presented at Court.

A 'Pearly King' selling Flanders poppies on the 11th of November, annual Remembrance (or Armistice) Day.

'Who will buy my sweet lavender?'—a familiar old London street cry.

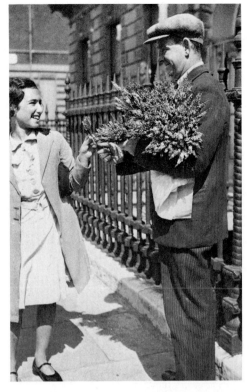

The original Caledonian Market for antiques and junk was situated before 1939 in a wide cobblestoned area in North London. After the war it moved to Bermondsey, south of the Thames.

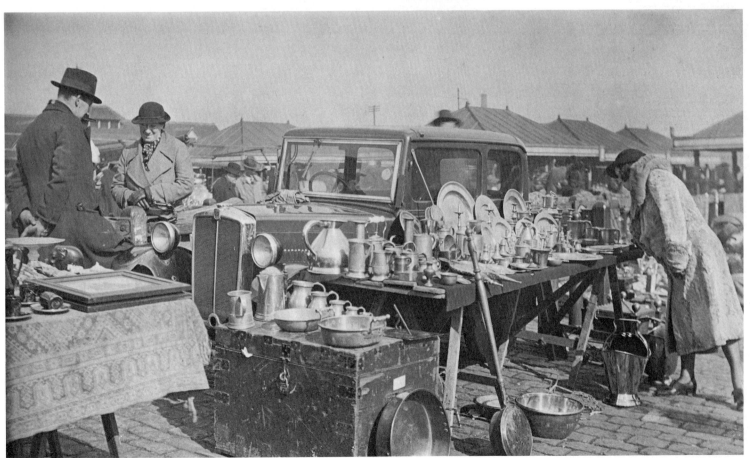

No. 4 Egerton Gardens, a Victorian red-brick house owned by my parents and lent to Alec Waugh and his Australian wife Joan for their wedding reception in 1932.

Up to the late 1930s, the owner of a house in which there was a seriously ill person could apply (and pay) for loads of straw to be laid on the street outside the house to deaden the noise of horse-drawn vehicles and motors. This picture was taken on an occasion in 1929 when my mother was seriously ill, and shows the straw set down outside our house.

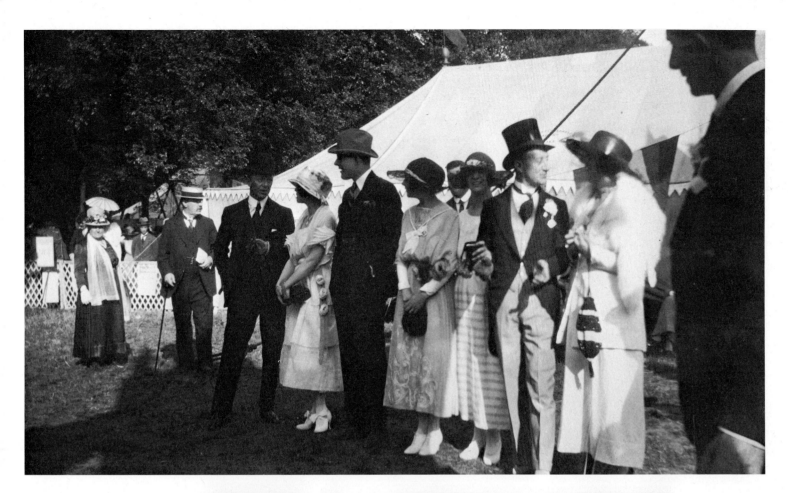

An annual charity event that took place at the Botanical Gardens, Regents Park, was the Theatrical Garden Party. Here, in 1922, are the cast of the famous musical comedy *Irene*, which included Edith Day, Pat Somerset and Robert Hale.

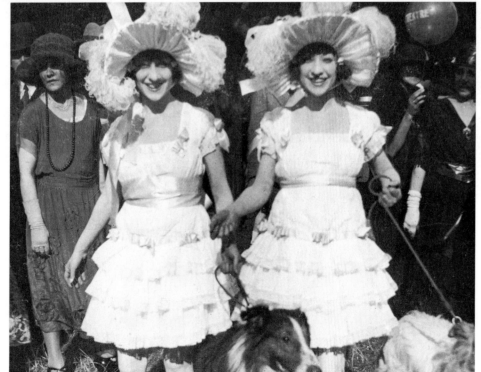

The Dolly Sisters, Rosie and Jennie, at the 1921 Theatrical Garden Party. They were appearing that year in a C. B. Cochran revue, *League of Notions*, directed by John Murray Anderson, famous for his many Broadway musical shows.

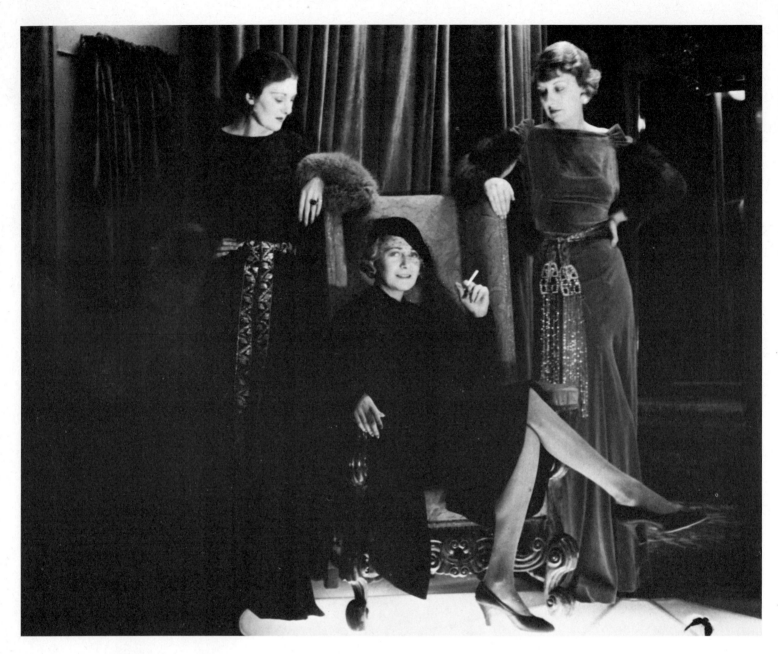

A friend who knew that I had been given a Leica in 1934
asked if I would take some pictures of the dress shop where
she worked in Grosvenor Street and of some of the
mannequins.

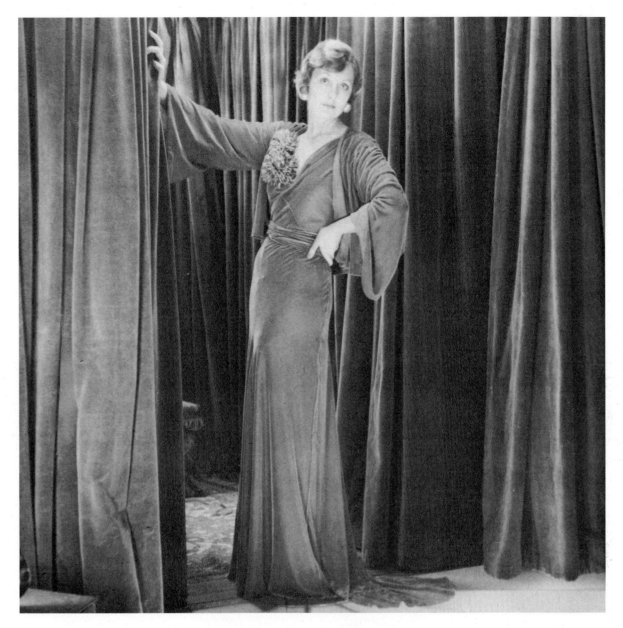

This dress would have been exactly right to wear at the famous Embassy Club in Bond Street.

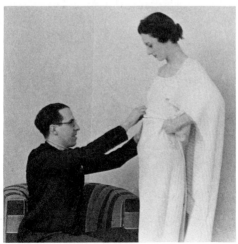

Victor Stiebel was a highly respected British *couturier* between the Wars, and indeed after the Second World War until the early 1960s.

A London florist in Berkeley Square advertises bouquets to be carried by debutantes attending Courts at Buckingham Palace when they were presented to Their majesties during the London social season.

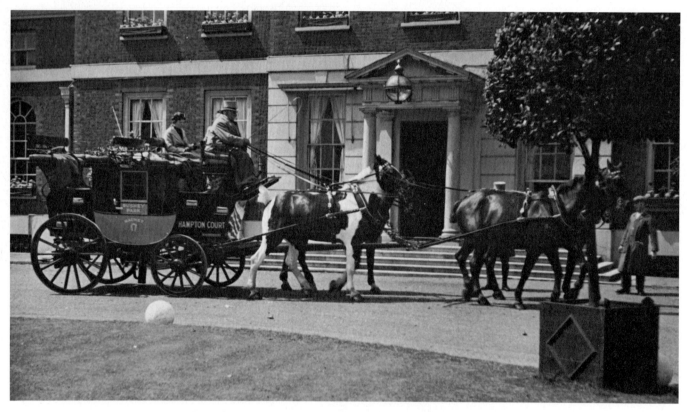

Ranelagh, a club founded in the 18th century on the banks of the Thames almost in the centre of London, was a victim of bombing during the Second World War. Its amenities included a magnificent club house, tennis courts, polo grounds, a golf-course, two lakes and an open-air theatre. At weekends a uniformed Hungarian orchestra played musical comedy tunes and Viennese waltzes.

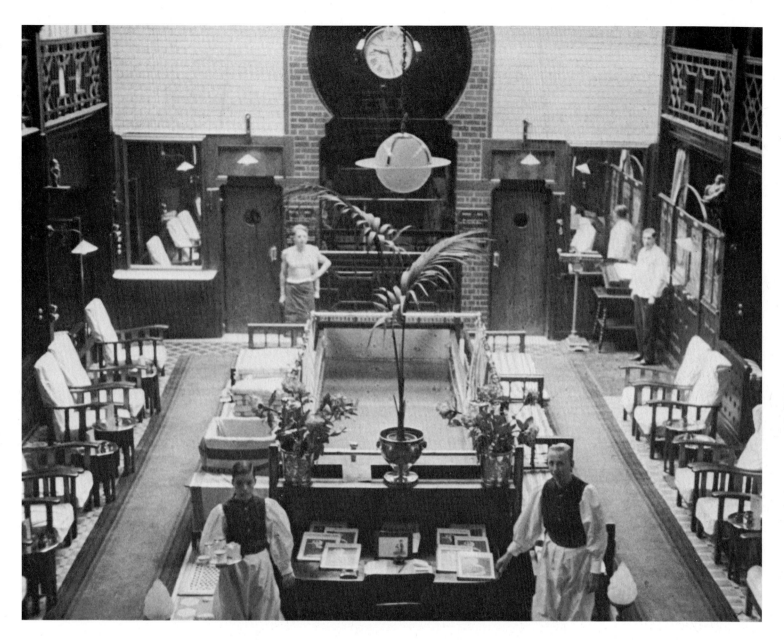

The Hammam Turkish Baths in Jermyn Street, just off
Piccadilly, had a plush Victorian decor and was much
frequented by famous jockeys trying to take off weight in a
hurry and smart men-about-town trying to lose their
hangovers. The cost of a visit was only 8s., and this included a
massage and use of the swimming-pool. During the 1941 Blitz
it was totally destroyed by a bomb and (alas!) never rebuilt.

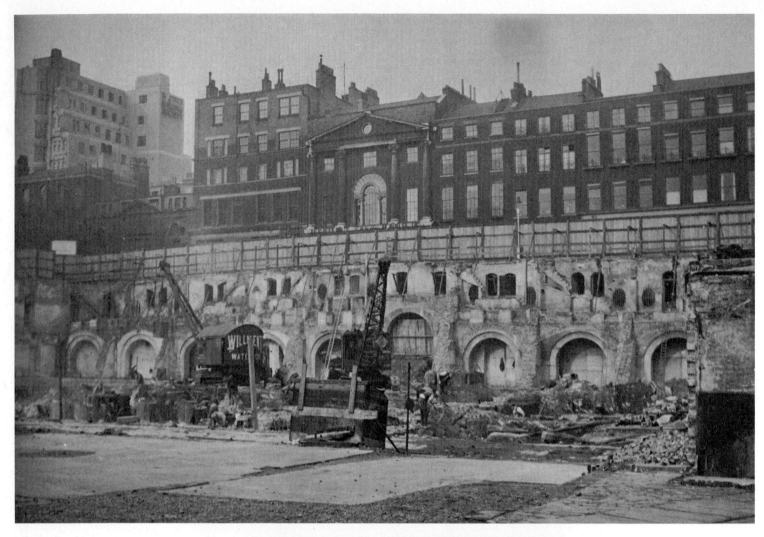

The beautiful Adelphi Terrace, facing the Thames and designed in the 18th century by the Adam brothers, was pulled down in 1935 and replaced by tall office buildings. Sir James Barrie had rooms at the Adelphi.

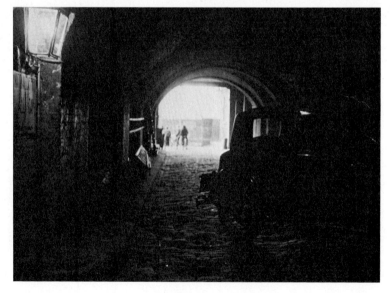

One of the rather spooky arches and passages underneath Adelphi Terrace, which functioned as wine-cellars, storage space, and sleeping accommodation for unfortunate down-and-outs and alcoholics. When showing interesting parts of London to friends from abroad, I used often to drive them through this labyrinth of tunnels.

The sad demolition of the old Alhambra Theatre, Leicester Square, which made place for the Odeon Cinema in 1936. The Alhambra was famous as a music-hall and the home of the early musical revues. *The Bing Boys* was a smash hit during the First World War and featured the song 'If You Were the Only Girl in the World', sung by George Robey and Violet Lorraine. The Diaghileff Ballets Russes were introduced to London in the Alhambra, and the great Pavlova danced there too.

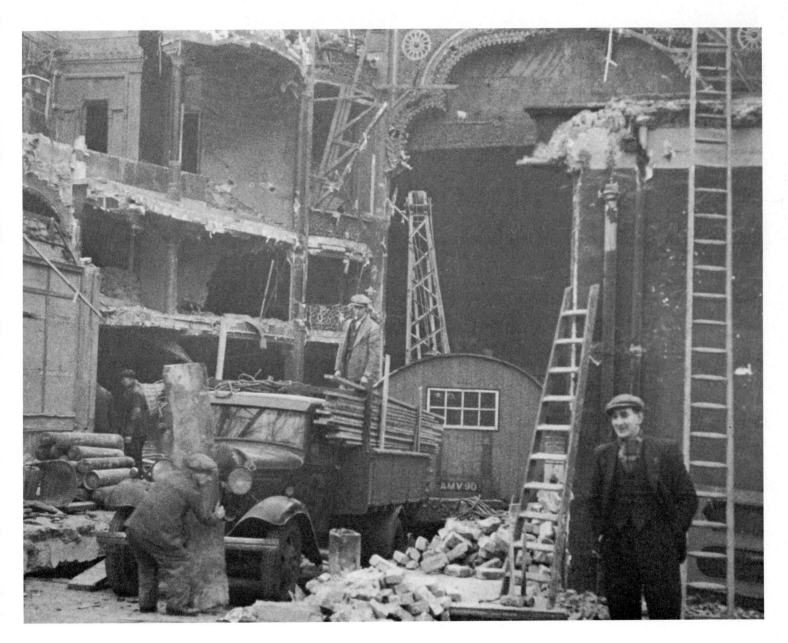

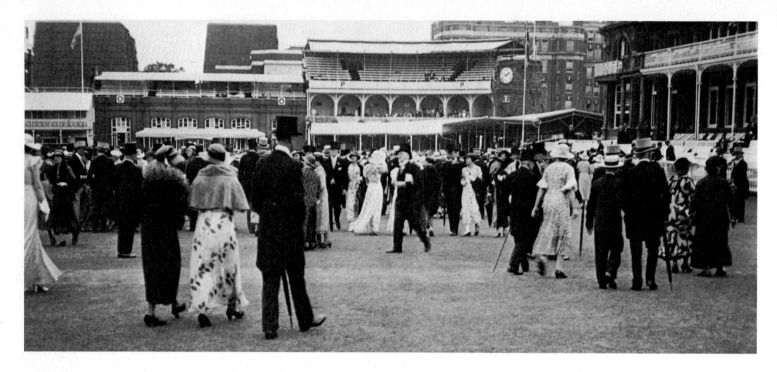

The annual Eton and Harrow cricket match was played in
July at Lords for well over a hundred years. It was a fashion
parade as well as a school sporting event—one of the
highlights of the London social season.

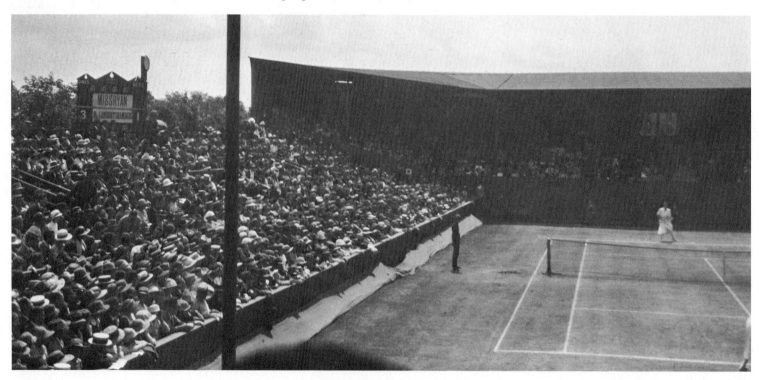

Wimbledon Lawn Tennis Club: the centre court in 1920
during the semi-final match between Mrs Lambert Chambers
of Great Britain and Miss Elizabeth Ryan of the U.S.A.
Mrs Chambers was the winner.

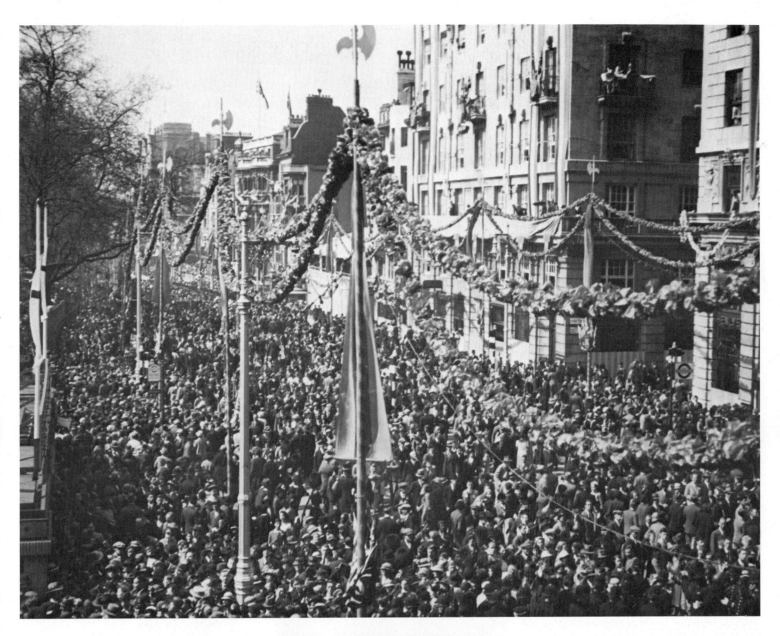

On 6 May 1935 my parents and I watched the Silver Jubilee procession of King George V and Queen Mary from a window at the Ritz Hotel. Old Mrs Thomas Manville of New York (mother of the well-known and much-married playboy Tommy Manville) had taken five rooms facing Piccadilly for the day. The moment her thirty guests arrived, a champagne breakfast was served, and after the

procession had passed we turned back into the rooms to find tables laid for a sumptuous buffet-lunch. In the largest room a three-piece orchestra played soft jazz.

The Royal couple received such overwhelming acclaim from the crowds lining the route that King George was reputed to have said to his consort, 'I never realized that they liked us so much.'

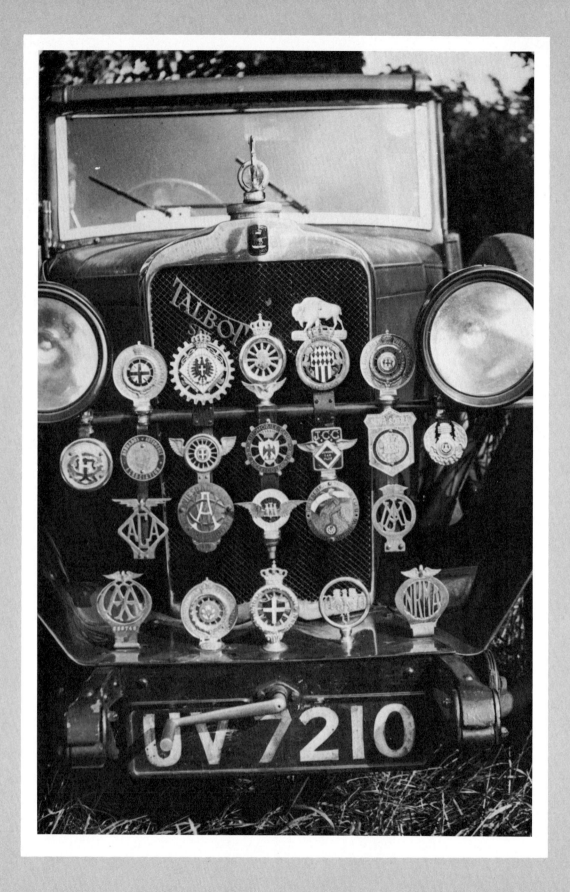

Motoring

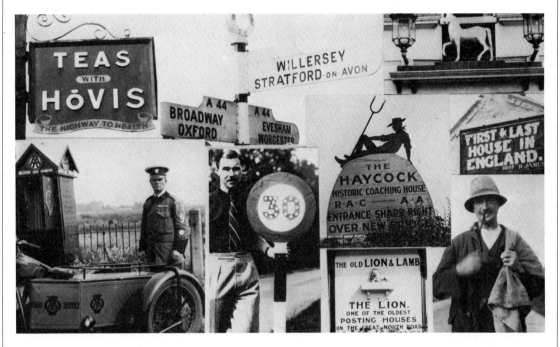

Where do we go from here?

◁ A collection of automobile club badges in the 1920s. Notice the cranking handle.

THE FIRST CAR I owned was a 1924 Morris-Cowley two-seater with a canvas hood and a 'dicky' seat at the back (with no hood over it). It cost £250.

My father gave me a few driving lessons in his Buick, and when the day came for me to take delivery of my Morris-Cowley I simply drove away, though (I must add) very nervously. In those days there were no driving tests, comparatively few private cars, no traffic wardens, parking meters or yellow lines by the curbs. Petrol was about 5 pence (Is.) a gallon. You could park your car in London for hours at a time in Bond Street or outside Harrods, but very few people left their cars out in the street all night. Everyone seemed to have some sort of garage.

My first long drive was on the old A.1 to Yorkshire, during which I passed perhaps a couple of dozen cars an hour. There were AA motorcycle and side-car patrols on main roads. Driving at nearly 50 miles an hour in an open car was an exhilarating experience.

I never owned a 'posh' car till I was sixty but I had often sat with my father in Hyde Park in the 1920s watching with envy as the long sleek Delages, Hispano-Suizas, Bentleys, Lagondas and the new American Chryslers drove past.

When I was at Cambridge in 1919, there were perhaps half a dozen undergraduates who owned cars. One was Prince Albert, later Duke of York and then King George VI. A man in my college had a Cubitt car, a make later to become extinct. A few undergraduates had motor bicycles with side-cars.

To take a motor car abroad was a major operation; even in 1936 when I took my Riley saloon to Ireland it was perilously loaded into the hold of a steamer at Liverpool.

The most beautiful car I ever saw was standing outside the old Berkeley Hotel on Piccadilly in 1930. It was an all-white Rolls Royce Sedanca de Ville, the body by Park Ward.

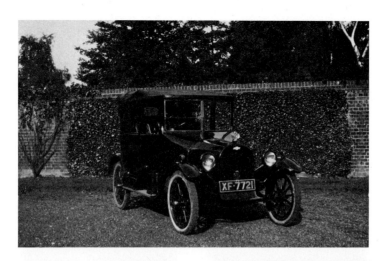

My father's first car, a Buick (1921).

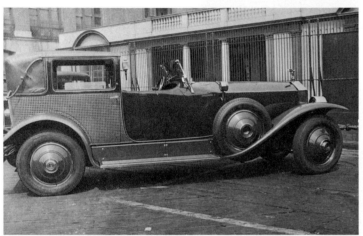

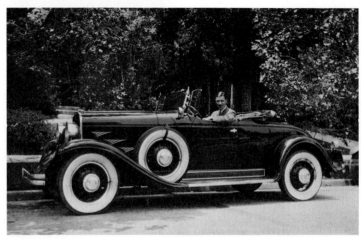

A Coupé de Ville Rolls Royce in New York belonging to Tommy Manville's sister, Lorraine.

A sporty Chrysler roadster—1933 model—in black and yellow.

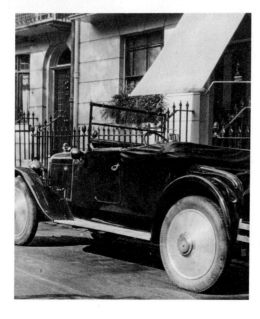

The second car I ever owned was a 12-horsepower Austin two-seater (with dicky-seat at the back); it was dark blue with shiny disk wheels.

My red-and-black 1934 Riley saloon.

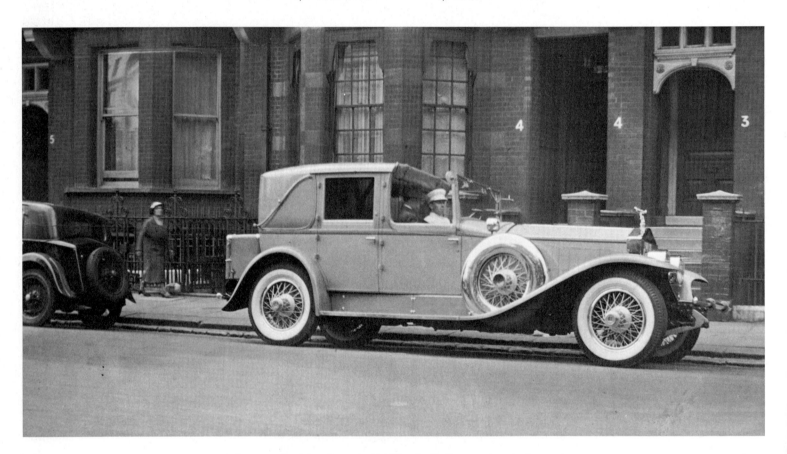

A fawn and white Coupé de Ville Rolls Royce that belonged
to Mrs Manville, whose fortune had been made from asbestos.
Each summer she brought her car to Europe, usually on the
S.S. *Bremen* of the Hamburg-America Line. Richardson, her
chauffeur, wore a uniform that matched the car's paint work.

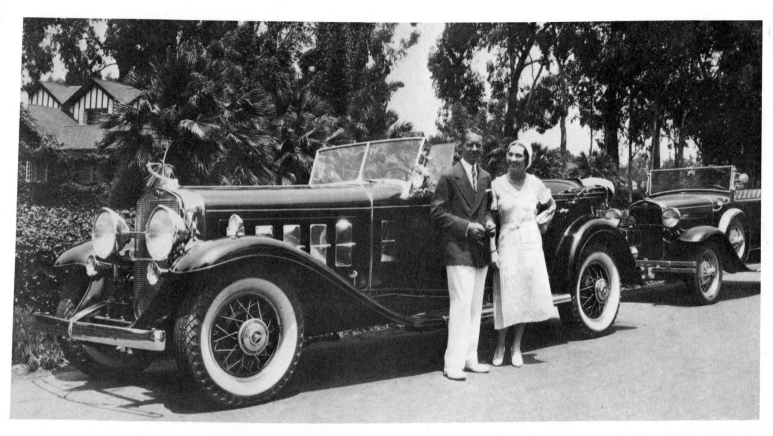

Eve Lee, a friend of my
California visits, posed
against one of the supremely
elegant automobiles of the
period. Beverly Hills, 1931.

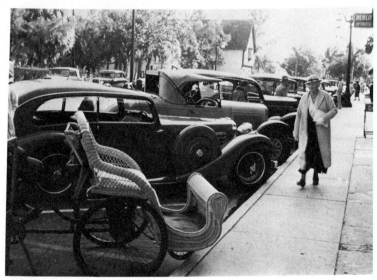

A car-park of the 1930s in
Palm Beach, Florida, which
could also accommodate an
invalid chair.

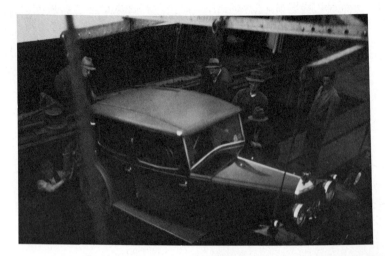

My 8-horsepower Riley aboard the British and Irish Steam Packet boat from Liverpool to Dublin in 1937. Only few cars made the voyage in those days and were carried in the hold.

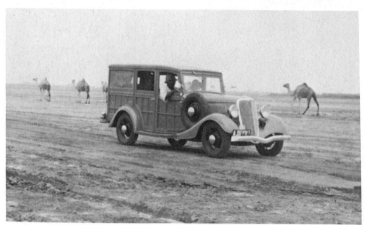

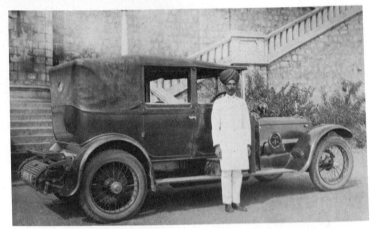

A journey in November 1936 across the desert from Port Sudan to Suakin, a deserted town on the shores of the Red Sea.

One of the Maharajah of Mysore's many cars, this one kept for the use of his guests.

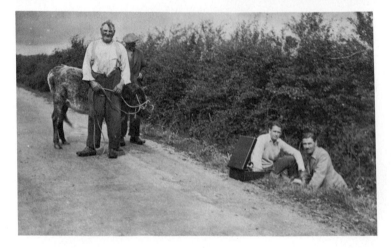

An astonished farmer, in an Irish lane near Cork, encounters me playing a George Gershwin tune on my portable wind-up gramophone.

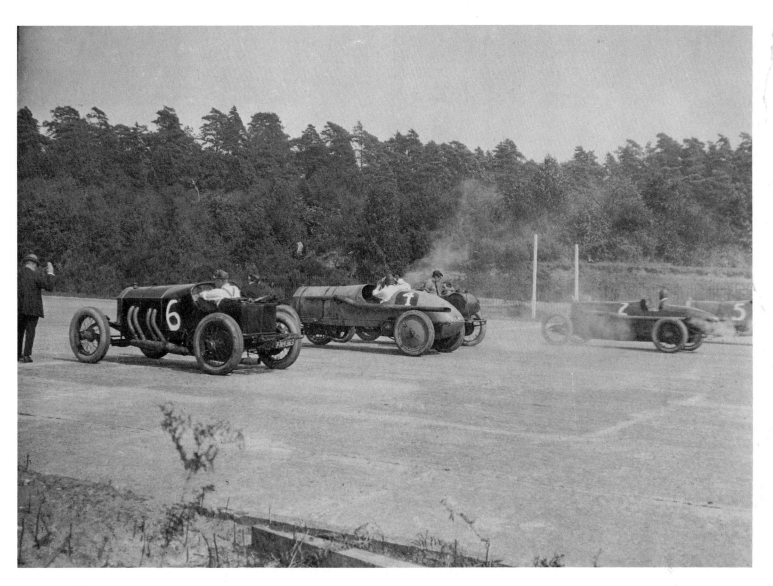

Brooklands motor racing track near London. In 1921 Count
Zborowski used to reach the then fantastic speed of 90
m.p.h. in his black Mercedes. I greatly enjoyed watching the
Bentleys, Sunbeams, and Straker-Squires whirling around the
track; today we would call them old 'Chitty Chitty Bang
Bangs'.

The Long Week-End

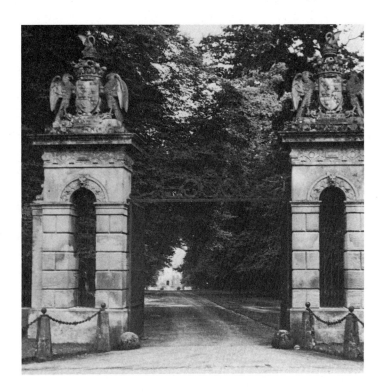

The entrance gates of Rufford Abbey, the stately home that belonged to the Savile family. In the reign of Henry VIII the site of a Cistercian abbey, built in 1148, was granted to the King's supporter, the Earl of Shrewsbury, and Rufford was built around it. Robin Hood's Sherwood Forest adjoins the property. During the Second World War Rufford was used by the army and most of the house is now derelict.

◁ A week-end party at a house in Berkshire belonging to Mrs Oscar Lewisohn, who had been the musical comedy star Edna May. Her original success had been achieved in New York in 1897 with *The Belle of New York* and also *The Catch of the Season*. In 1905 she married an American millionaire, came to London to play the part of the Salvation Army lass again and became the toast of the town. She once told me that when she went to play in Oxford, her train was met at the station by some adoring undergraduates, who unhitched the horses from her hired carriage and themselves pulled it through the streets to her hotel.

43

WHEN I WORKED in a London shipping-office in the 1920s I first began to enjoy week-end invitations to country house parties.

I had a car, played tennis, could dance the Charleston, and got my clothes in Savile Row. My portable gramophone records were mostly sent from America—an unheard-of luxury.

A house with a large staff, grass and hard tennis-courts, with a nearby golf course, made it easy for hosts to entertain week-end guests. The men wore plus-fours, 'Oxford bags', and in the evening double-breasted dinner jackets that had just become the fashion, after the Prince of Wales started wearing them. From the best tailors these cost £20.

Friends of my parents, who lived in London, always rented a house near Henley-on-Thames at the end of July, when the London social season was over. Each of their three daughters was allowed to invite a young man each week-end. One week-end evening, when we were playing hide-and-seek, I hid in the butler's pantry. I picked up a large piece of paper from the floor on which was written a list of frequent guests and the size of the tips they usually gave! My name had only 10s. beside it—not a bad tip in those days, but it looked rather meagre when compared with some of the others.

Occasionally I stayed in very grand houses with at least thirty guests and almost as many servants. Once when I was getting out of my small car the butler greeted me with the words, 'Will your manservant be coming later?' I replied, 'Good heavens no, I don't have one.'

'In that case, George the third footman will have to look after you.'

One's clothes were pressed every day, a bath run in the mornings and even postage stamps were available on writing desks.

For me, the best week-end parties were those by the sea. I had wonderful friends who lived in a house called 'Cottington' at Sidmouth, in Devonshire. We would swim, play tennis, croquet and play my American dance-records on my portable gramophone. It was the first time anyone of my acquaintance had heard 'Tea for Two'. On Saturday evenings, after going to the local cinema, we went to Trumps Café and danced to a piano, played by a woman.

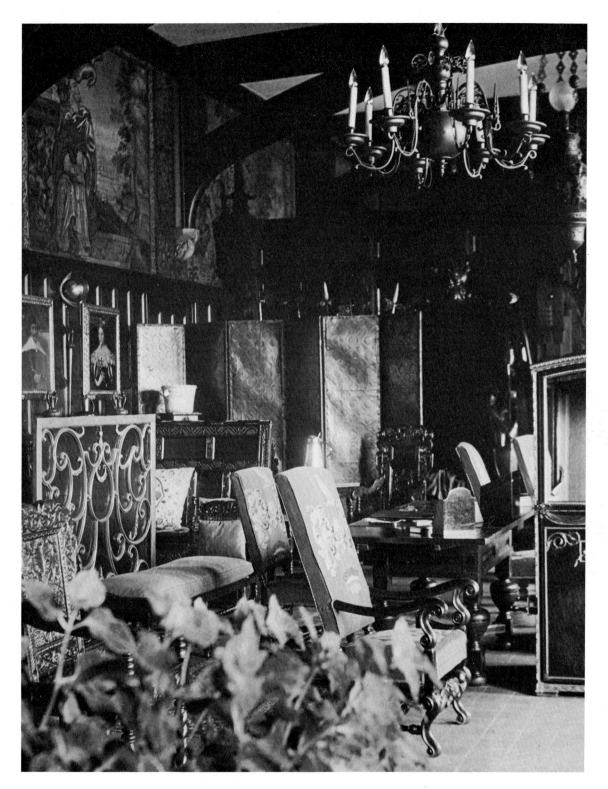

The hall at Rufford, showing some of the Flemish tapestries, a
sedan chair, an Elizabethan cradle and a child's chair. King
Edward VII often stayed at Rufford for the autumn Doncaster
race meeting. He was not known as the easiest of guests. He
did not care for the sombre colouring of a tapestry bedroom
allotted to him, so, since he was a frequent guest, one was
specially redecorated in white and gold and was always
known as the King's Room.

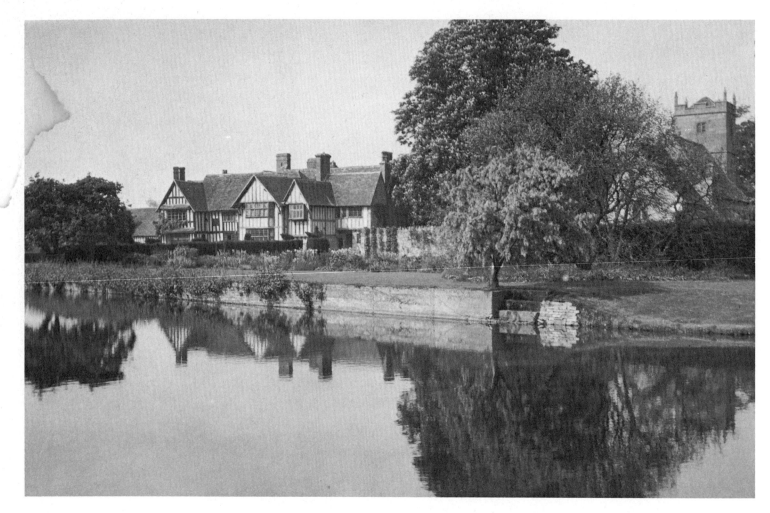

Wickhamford Manor, in the Vale of Evesham, Worcestershire,
is a glorious half-timbered Tudor manor house with walls of
mellow Cotswold stone. There have been no additions to the
house since 1470, but the inside has been modernized with
skill. Before the Manor came into the hands of the Crown in
1539 it belonged to Evesham Abbey and was a retreat for
monks. In the reign of Queen Elizabeth I, the Manor became
the property of the Worcestershire family of Sandys, through
whom there is a connection with George Washington.
Penelope Washington, daughter of a Mrs Elizabeth
Washington who married a Samuel Sandys, is buried in the
church adjoining the Manor; the Washington coat of arms is
'Argent two bar gules in chief three mullets of the same'—
or, in other words, three stars and three stripes. Could this
be the origin of the stars and stripes on the American flag?
When I used to visit the Manor it was owned by my friends
the Lee-Milnes.

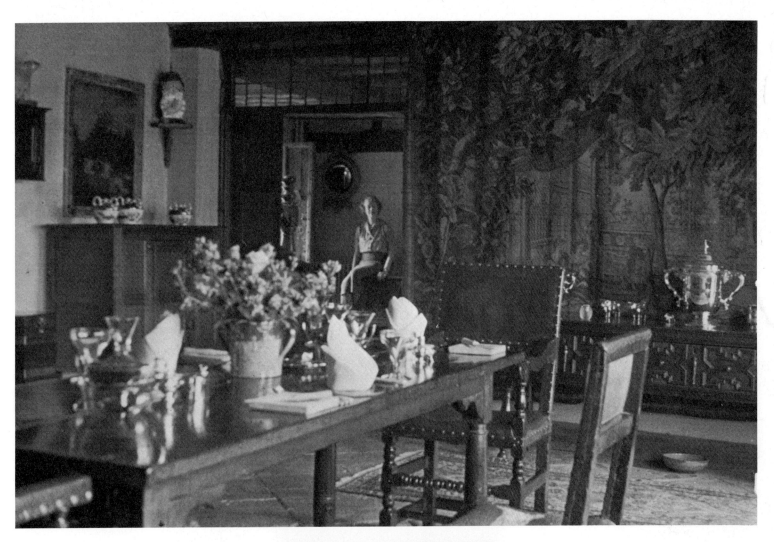

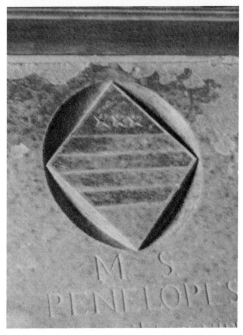

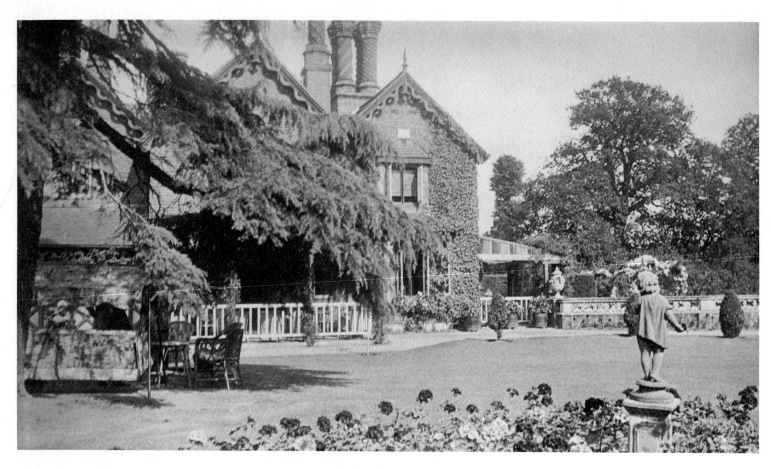

The Maharajah of Rajpipla's country home in England was at
Old Windsor where he entertained lavishly during the
summer months. His racehorse 'Windsor Lad' won the Epsom
Derby in 1943.

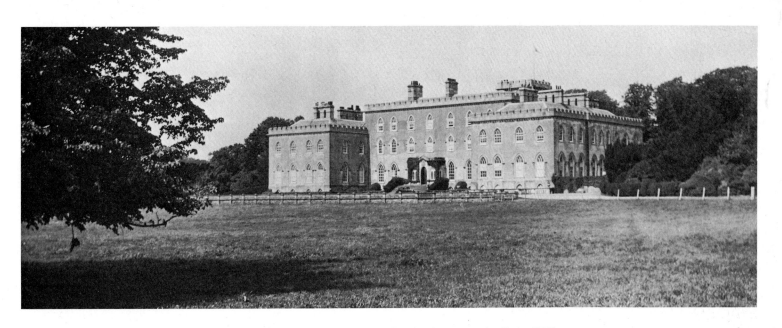

Moore Abbey, Monasterevin, Co. Kildare, was built in 1770.
In the 1930s it was rented from the Earl of Drogheda by my
good friend John McCormack.

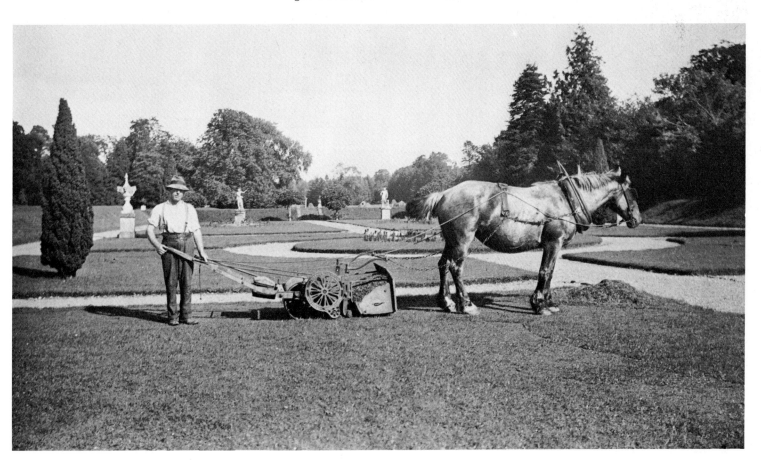

A 19th century horse-drawn lawnmower at Moore Abbey
where I stayed in 1937 with John and Lily McCormack and
learned to love the lush Irish countryside.

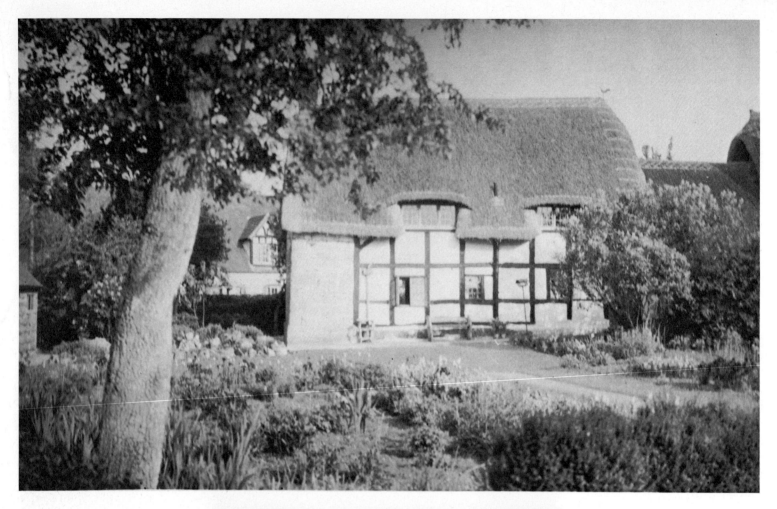

Weathervane Cottage at Wickhamford, not far from Broadway in Worcestershire. I rented this thatched roof cottage in 1936 from the owners of the Manor for £50 a year. It had two living-rooms, two bedrooms, an acre of garden and a garage. It had been built in the 17th century but had all modern conveniences.

At the 1938 Evesham 'Mop', a fair dating from the Middle Ages, an ox is roasted in the main street.

The interior of the Fleece Inn at Bretforton, not far from Stratford-on-Avon, Worcestershire. When I discovered it, the brass shone, the oak beams were polished to shine like satin, there were huge log fires in winter and always the most hearty of welcomes. It represented to me the unspoilt rural life of England.

One of the Inn's oldest customers in his 'Sunday best'.

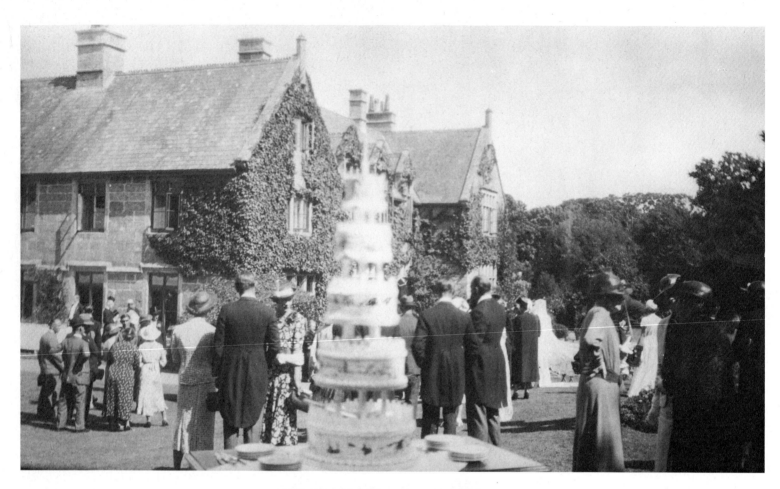

A summer country wedding
in Cornwall. The bride
receives the guests on the
lawn and the four-tiered
wedding cake waits to be
cut.

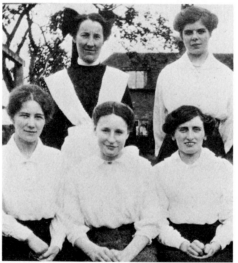

My Aunt Mab's staff in 1917.
Augusta, the Swiss parlour-
maid who served her for
forty years, is wearing her
black bow and apron.

On the Isle of Wight, Cowes ▷
Regatta Week in 1934: a
view on the lawn of the
famous Royal Yacht
Squadron, taken from the
club house.

The yacht *Fantome*, the
guardship H.M.S. *Rodney* and
the royal yacht *Victoria and
Albert*. The picture was taken
from the Cowes Parade, just
after sunset as lights began to
appear.

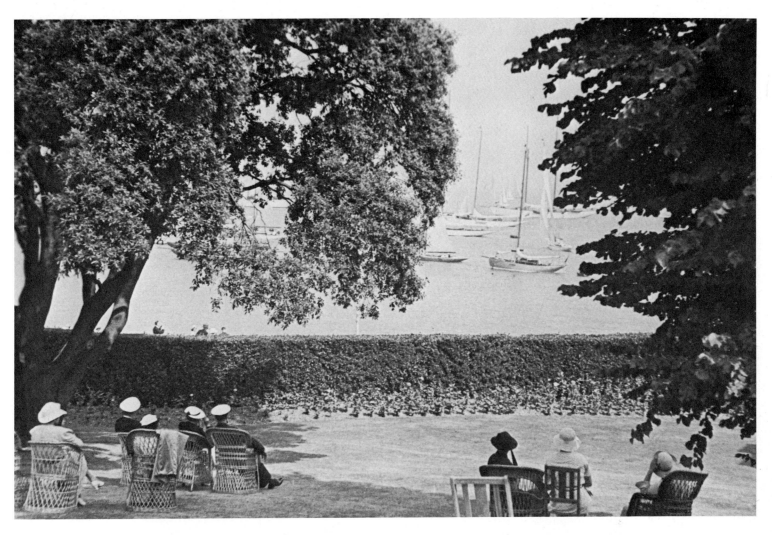

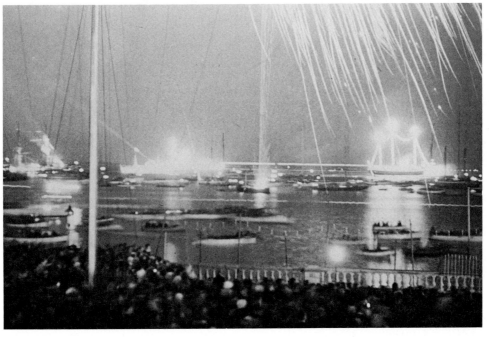

Going Abroad

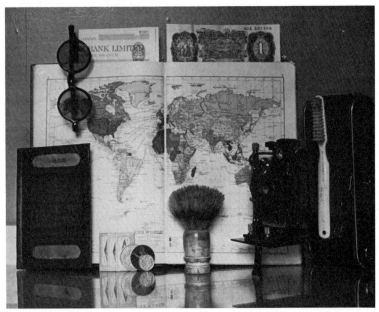

Travellers' requirements.

◁ The S.S. *Aquitania*, one of the great Cunard Line transatlantic ships.

TRAVEL used to be leisurely and predictable. In 1922 I went to China on the traditional slow boat, a small P and O liner called the S.S. *Dongola*. As far as I can remember, it took six weeks with stops at Marseilles, Port Said, Suez, Aden, Bombay, Colombo, Penang, Singapore, Hong Kong. These port calls were usually fairly lengthy and gave passengers time to go on shore and see the sights.

Every night we changed into evening clothes for dinner; we played a lot of deck games and had ship's concerts and bridge tournaments. My parents always took their own long cane deck-chairs with them on sea voyages.

Before the rush of air travel long sea and rail voyages were restful, happy experiences. There was the luxurious Blue Train from Calais to the South of France or the celebrated Orient Express across Europe to Istanbul. On these de luxe trains the passengers were cosmopolitan, and the food in the restaurant cars was as good as that provided by any first-class hotel.

I have also enjoyed walking holidays in the Yorkshire Dales, with bed and breakfast at comfortable wayside inns for 5s. a night, as well as a golfing week-end at Le Touquet where I could watch the Dolly Sisters and Mr Gordon Selfridge at the casino gambling with thousands of pounds.

Of all the voyages I have taken perhaps the one on the Cunard liner *Mauritania* in 1922 gave me the biggest thrill. To find ballrooms, vast restaurants, passengers of every nationality looking as if they had all stepped out of a fashion magazine, was dazzling. I had never expected to find it all so vast—swimming baths, gymnasiums, Turkish baths, shops, libraries, hairdressers; in fact, a floating hotel.

The stewards and stewardesses on British liners were considered in those days to be the finest in the world for efficiency, and perfect good manners and kindness.

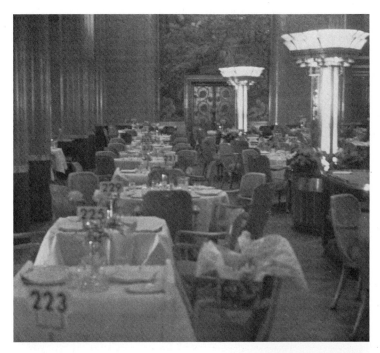

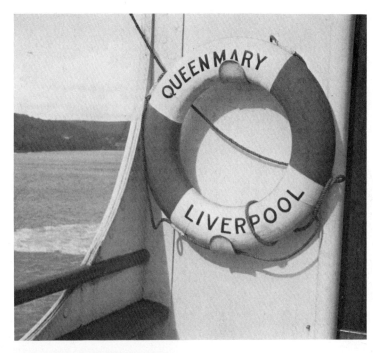

The S.S. *Queen Mary* on sailing day for New York.

Boxes of flowers and other presents sent to passengers just before embarkation.

In 1920 I persuaded my father to take me on one of the first commercial London-to-Paris flights from Croydon. Our craft was a converted Avro reconnaissance warplane that belonged to 'Aircraft and Transport Travel Ltd.' One-way fare was £25, and we took off from a grass runway. There were only two seats for passengers; the pilot sat outside in the cockpit.

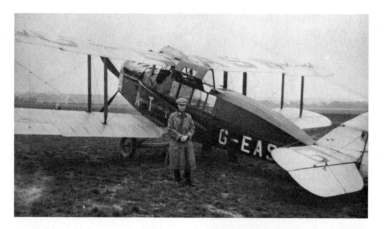

Speaking through an intercom telephone, he told us that we would be flying at 4,000 feet, and all being well we were due to land at Le Bourget, the Paris airport, in 2½ hours. At 60 m.p.h. we actually made the trip in 2 hours, and good visibility made it possible for us to see the war-devastated parts of France: trenches, shell craters, abandoned tanks and gun-emplacements.

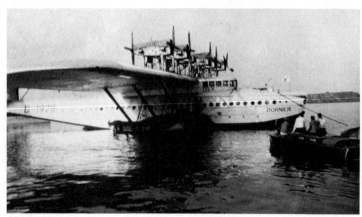

The giant German flying-boat *The Dornier-Dox* moored near New York, having flown across the Atlantic in stages (1932).

Croydon Aerodrome, international even in 1934.

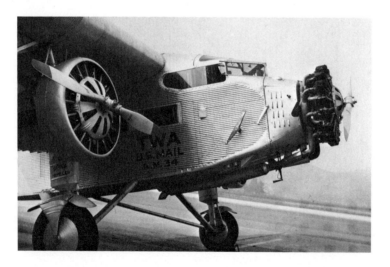

A Trans World Airlines plane carrying the U.S. mail from Central Airport, Glendale, California in 1933, a twenty-six-hour flight to New York.

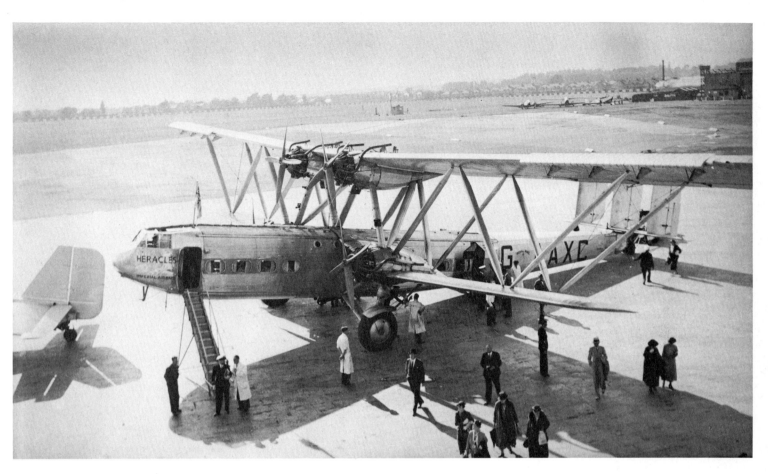

Croydon Aerodrome in 1934: a London-Paris Imperial
Airways 'Hercules' plane.

The Chief, crack train of the Atchison, Topeka and Santa Fe Railroad from Chicago to Los Angeles in 1931. *Right*: Blocks of ice are being loaded into the roof of the dining-car at a wayside station. This was a rudimentary but effective form of air-conditioning. I spent three nights on this train, travelling eastward in sweltering heat. There were thirty passengers in my compartment, and I was lucky to have a lower berth at night.

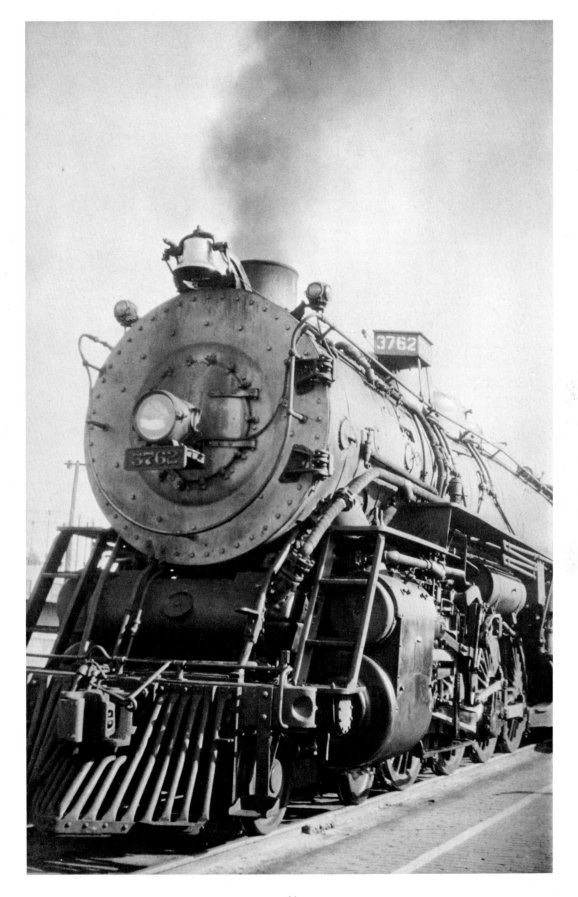

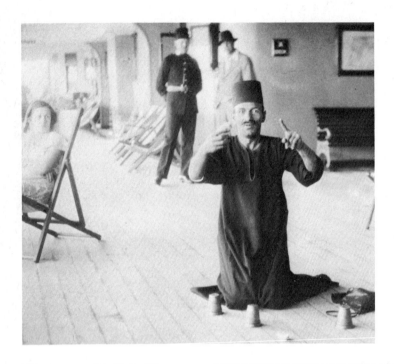

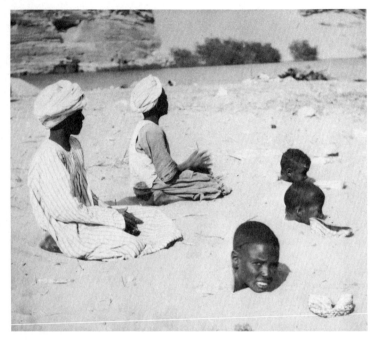

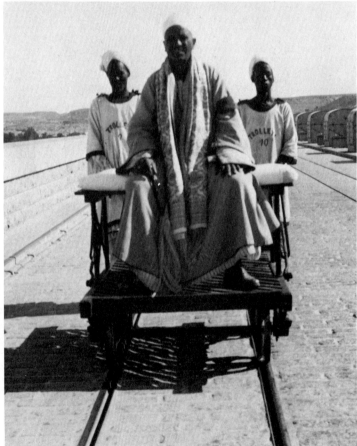

The famous 'Gulli Gulli' conjuror who used to board all passenger ships at Port Said. He would produce eggs, flower-pots or chickens out of passengers' ears, keeping up a steady flow of patter.

Elder boys buried their young brothers in the sand and then called to passing tourists for baksheesh. For such an ingenious ploy they usually received a few pennies.

My dragoman in his loose blue silk *galabiya*, on the rail line on which we travelled the whole length of the famous Nile dam at Aswan. Two youths pushed our trolley.

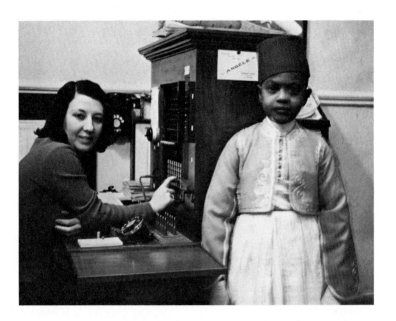

Violette, born in Roumania, was telephone operator in 1936 at Shepheard's Hotel in Cairo. She spoke six languages fluently, but Arvad, one of the hotel pageboys, spoke only Arabic.

A desert camp for enterprising tourists, an hour's camel-ride from Mena, near Cairo. The silence here was absolute. At night the moon silhouetted the pyramids and was so bright I could see the hands of my wristwatch.

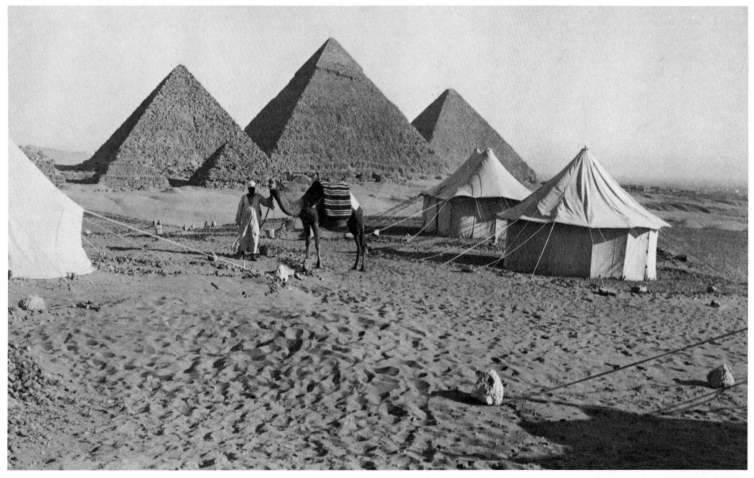

63

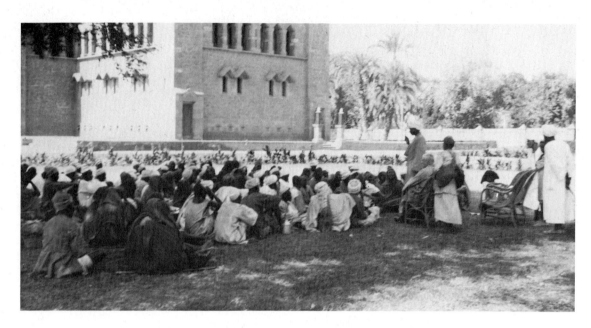

The Anglican Bishop Gwynne divided his time between
Khartoum and Cairo throughout the year. While I was in
Khartoum he had a meeting of the aged poor each Sunday
afternoon under shady trees. They sat on the grass while he
told them stories from the Bible in Arabic.

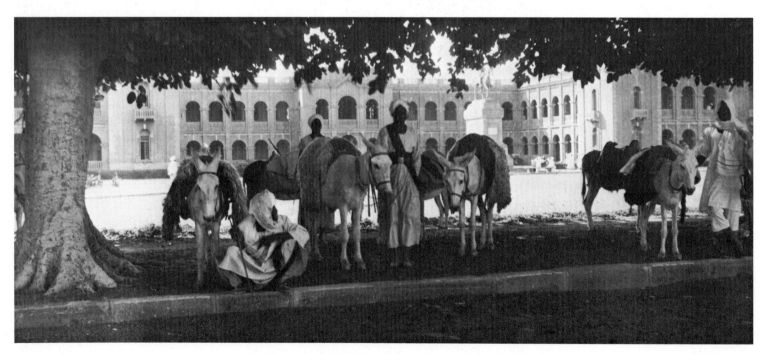

Sheiks on their way to pay their respects to the
Governor-General in his palace in Khartoum.

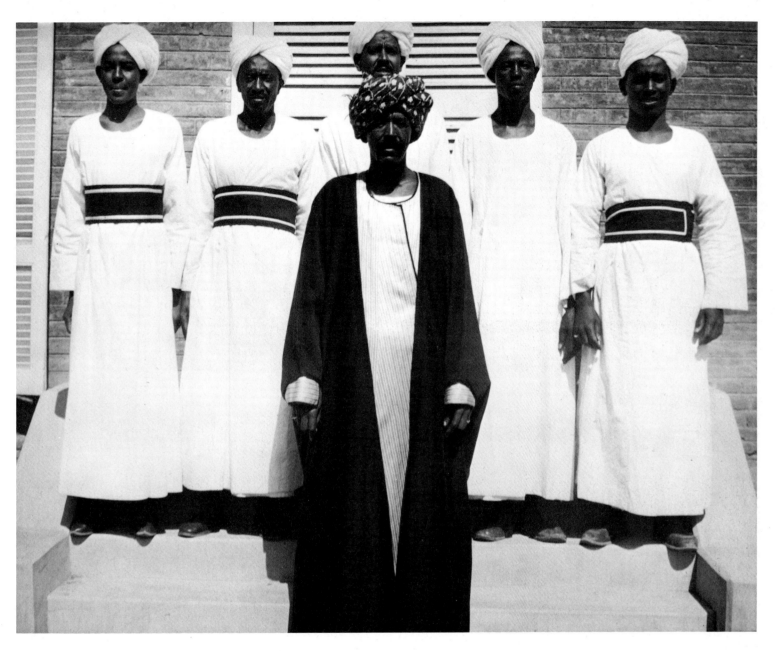

Abdul the butler and his staff at the house where I stayed in Khartoum. In 1936 it was the official residence of the Kaid El 'Amm, the British Major-General in command of the Sudan Defence Force.

Atbara Station, a well-known railway junction halfway between Khartoum and Port Sudan on the Red Sea. Standing in the station can be seen the train which was called by the British 'the Sunshine Express'.

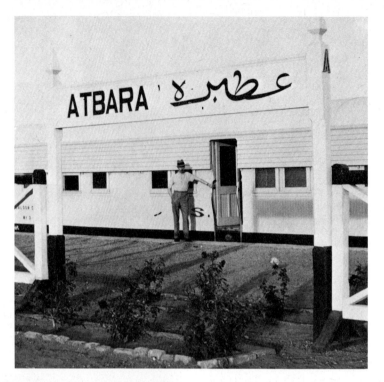

'Come to Lincoln for your next holiday' was the surprising poster on the wall of a small railway station in the Sudan.

'Sudan Handicraft': tourists inspect the native wares displayed on the ground.

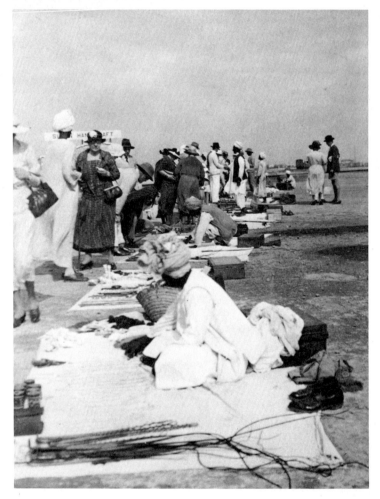

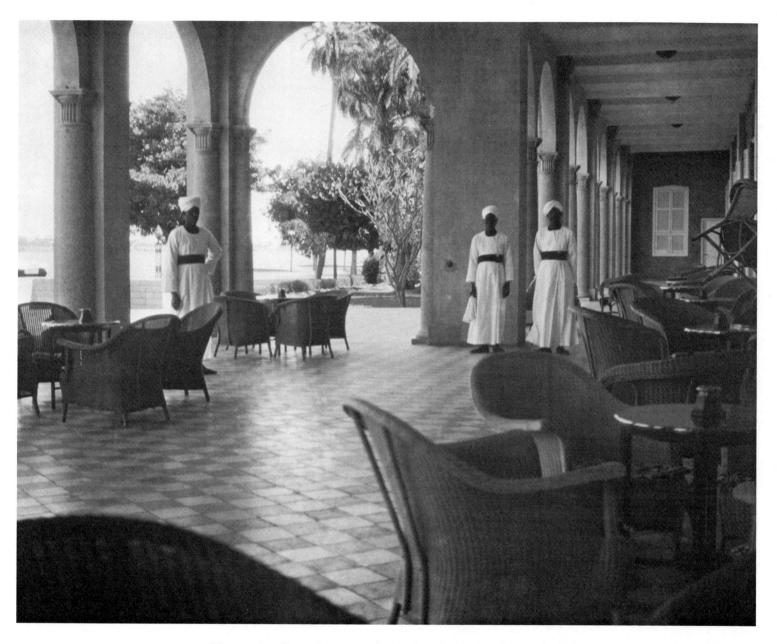

The marble-floored terrace of the Grand Hotel in Khartoum, facing the Nile. The hotel is situated near the palace where the British Governor-General then lived. In 1885 General Gordon was standing alone on the white marble steps here when he was hacked to death and his head was cut off by the Mahdi's dervishes.

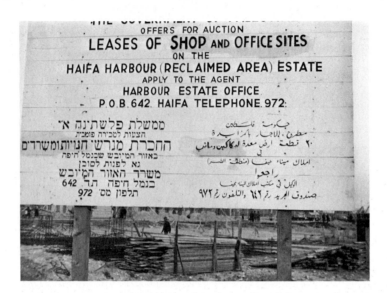

THE GOVERNMENT OF
OFFERS FOR AUCTION
LEASES OF **SHOP** AND **OFFICE SITES**
ON THE
HAIFA HARBOUR (RECLAIMED AREA) ESTATE
APPLY TO THE AGENT
HARBOUR ESTATE OFFICE
P.O.B. 642. HAIFA TELEPHONE. 972.

Haifa, 1936: an estate agent's poster in three languages.

Members of the Palestinian Police Force locking up a suspected criminal in a prison van in Jerusalem in 1936.

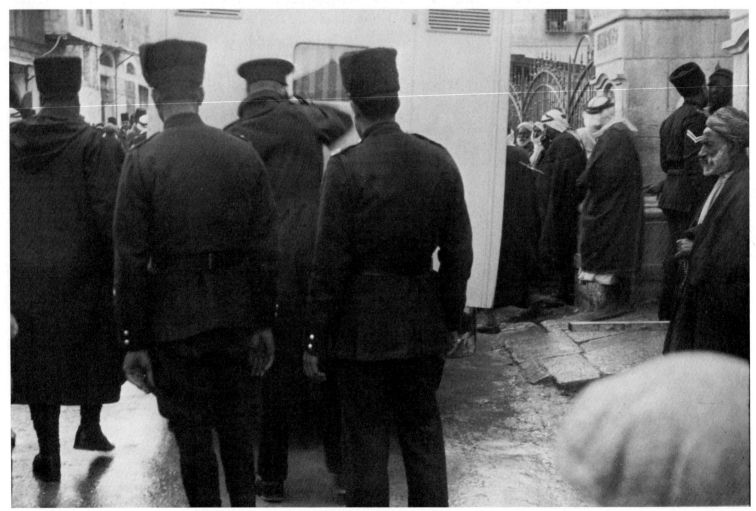

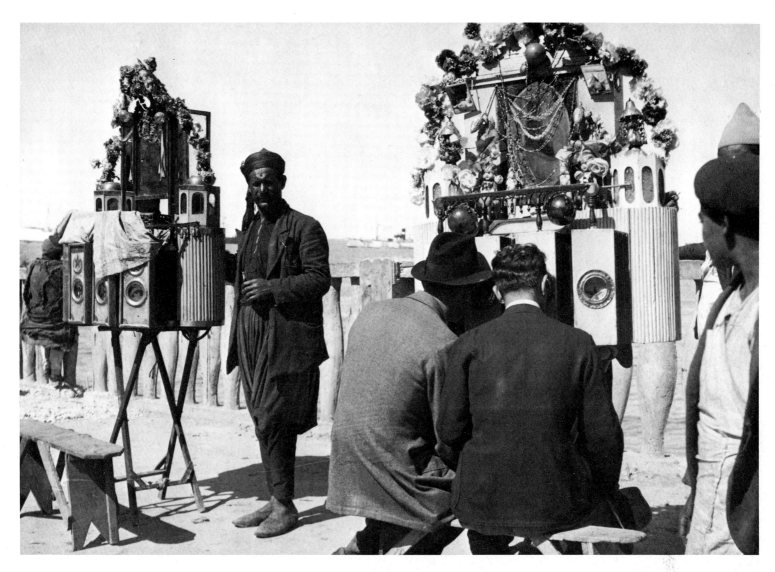

An enterprising Arab's home-made movie. He turned a handle while singing and you saw coloured postcards of Haifa.

A Jew and an Arab survey the busy harbour at Jaffa in Palestine, 1936.

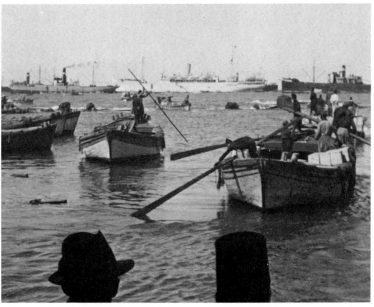

Rajpipla State, although quite tiny, had its own railway and a luxurious special train that was sent to pick up arriving guests at the border town of the Bombay Presidency. I was sorry that none of my friends was there to see my stately progress.

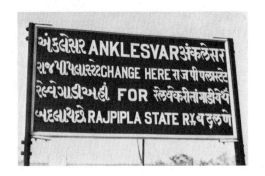

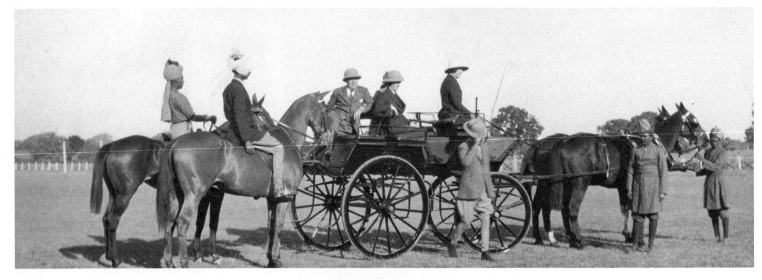

Most mornings the Maharajah drove from his palace to join those visitors who were staying in the large Guest House for a ride on one of his polo grounds. Then he would remain with us for breakfast on one of the large verandahs, waited on by servants dressed in white with the Rajpipla State colours round their waists and turbans.

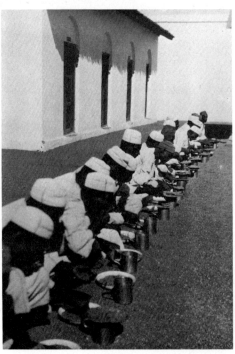

State prisoners at Rajpipla having their midday meal. I was escorted round the jail by the doctor. When I told him I felt embarrassed he said, 'They enjoy any diversion!'

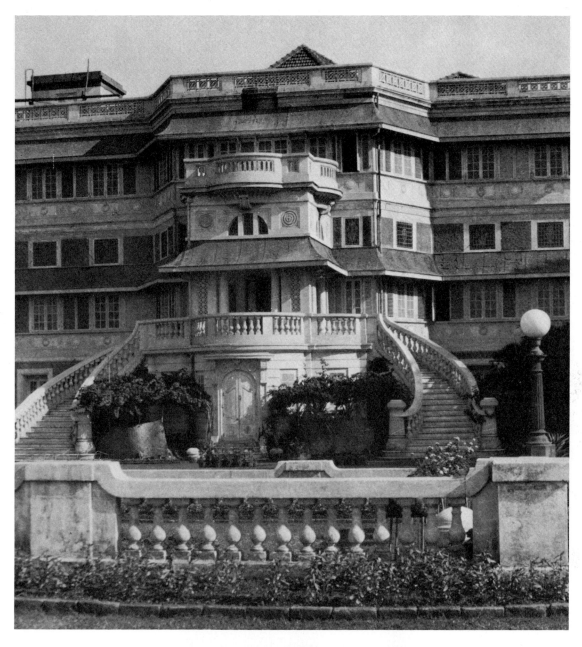

The Maharajah of
Rajpipla's white marble
residence in Bombay.

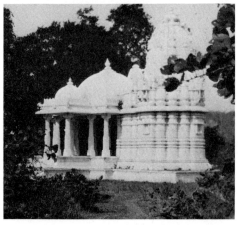

A romantic jungle
setting for a temple
in Rajpipla State.

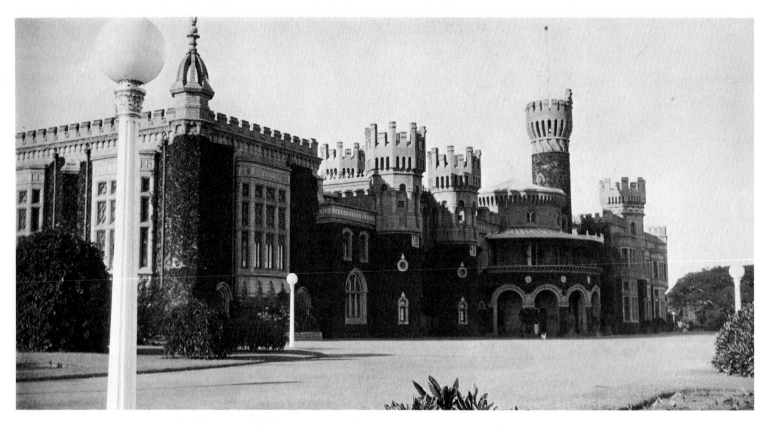

The Maharajah of Mysore's palace at Bangalore. His guests
were accommodated in a sixty-bedroom mansion called
'Lalita Mahal'. The rooms and corridors were vast, the staff
consisted of sixty; bar a couple of sanitary engineers from the
U.S.A., I was the only guest.

'I dreamt that I dwelt in marble halls'—and saw a repre- ▷
sentative of the British Raj pointing to the future of India.

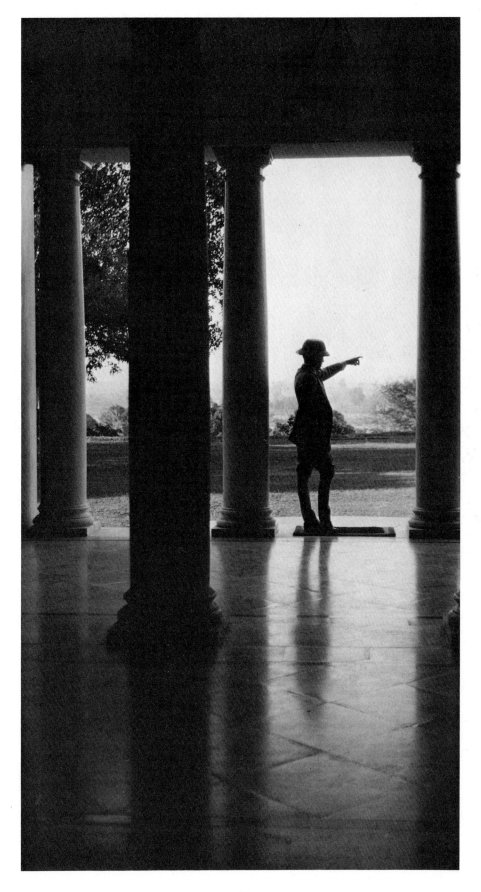

Stockholm, 16 June 1938: Prince Bertil of Sweden in the royal box at the parade celebrating the eightieth birthday of King Gustav. The next day, with the Crown Prince and Princess, he left for the United States on the *Kungsholm* to participate in the tercentenary of the first Swedish settlement in America, on the banks of the Delaware River.

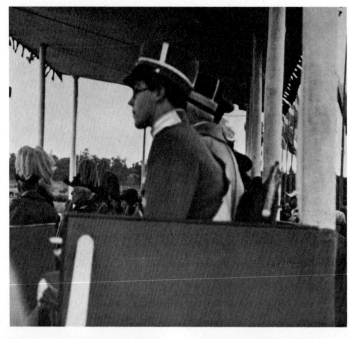

At the factory of the Swedish Match Co. in Jönköping, I was given a presentation box about 4 ft. long containing about 200 different-sized boxes of matches.

At Fagernes in Norway, Andrea Hauge plays a 1719 musical instrument—the Langeluke ('long plaything').

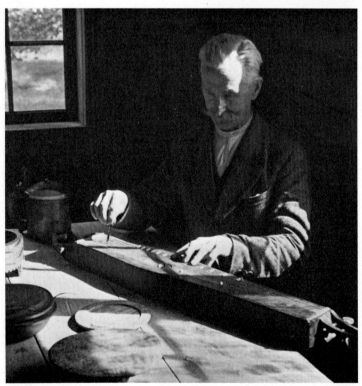

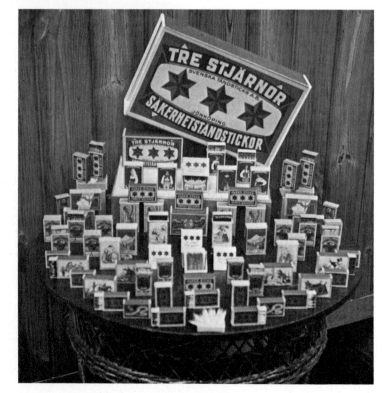

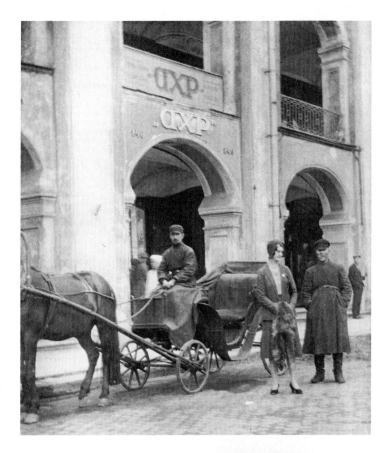

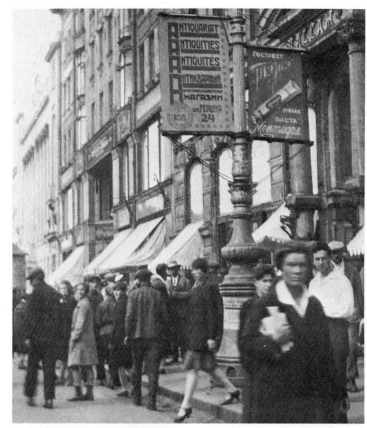

Leningrad in 1929. The Nevsky Prospekt, the Fifth Avenue of Peter the Great's magnificent city on the banks of the Neva river.

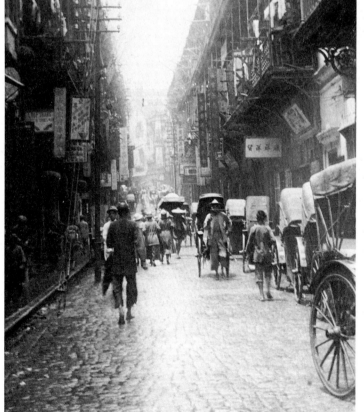

A busy street in Canton, 1922.

'Monarch of all he surveys': a scene on a sheep station in the
State of Victoria, Australia.

An Australian 'buggy' and the owner of a large sheep station
in New South Wales.

Australia's famous Sydney Bridge in 1931, six months before ▷
its completion.

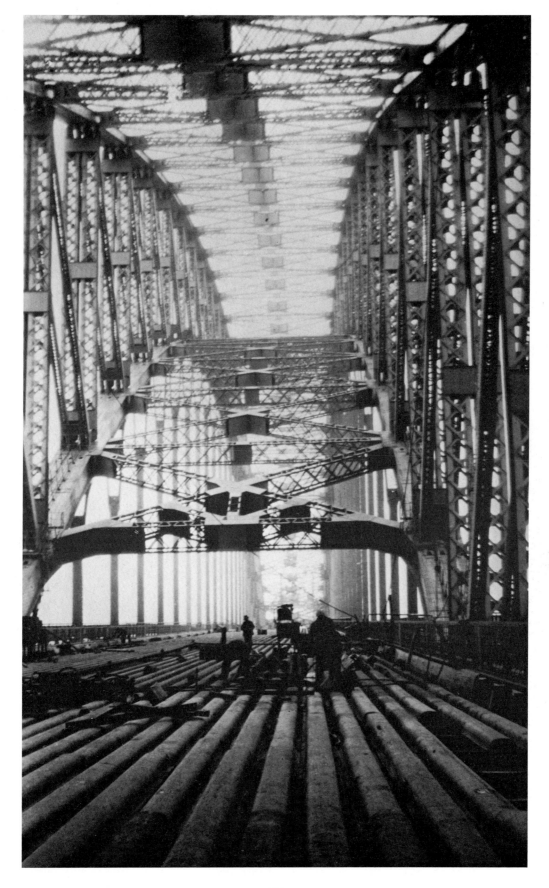

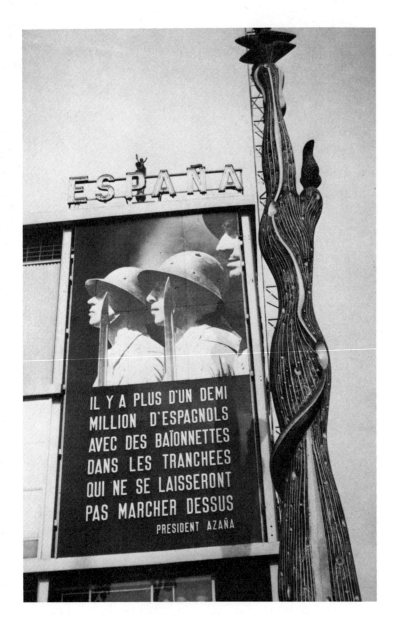

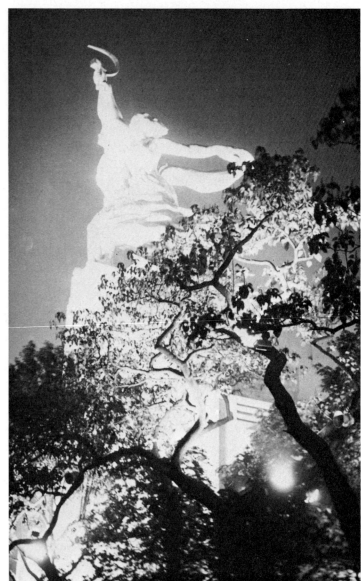

The 1937 International Exposition in Paris. Two of the most arresting pavilions were those of Spain and the USSR. The latter was strikingly floodlit at night.

Packing problems.

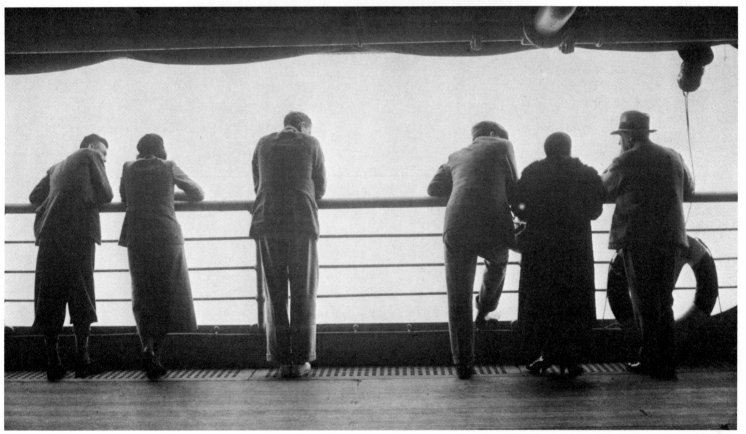

'Journey's End'.

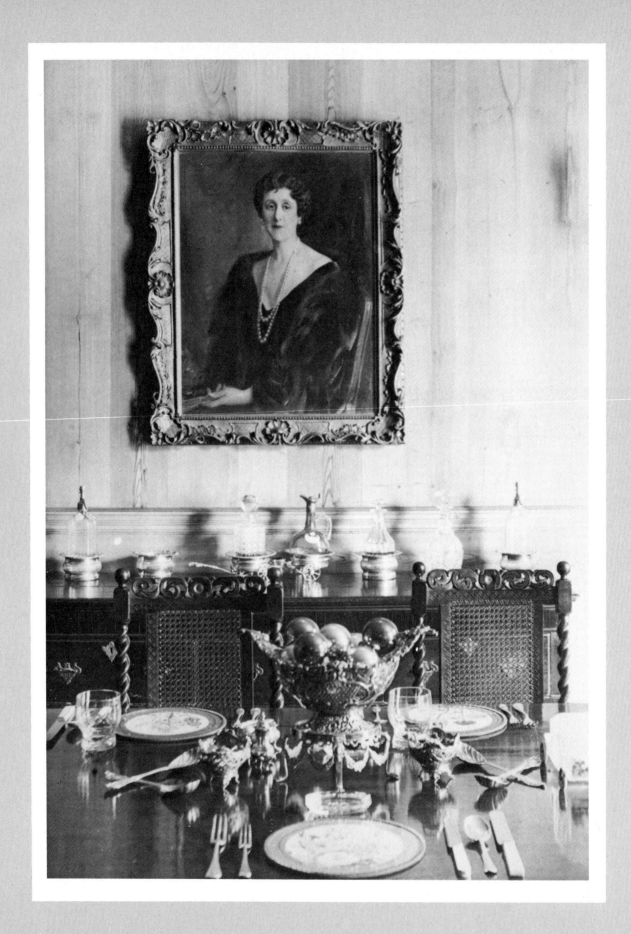

Dining Out

MENU
LANSDOWNE
HOUSE.

CHAUD.
Consommé de Volaille en Tasse.

FROID.
Filet de Saumon à la Richelieu.
Escaloppes de Homard à la Cardinal.

Petites Bouchées à la Reine.
Suprême de Volaille Jeannette.
Côtelettes d'Agneau Petits-Pois.
Galantine de Veau aux Truffes.

SALADE.
Poulet, Langue, et Jambon.

SANDWICHES.
Jambon, Volaille, Langue.
Foie Gras. Petits Pains.

Savarins aux Fruits.

Gâteau Moix, Mascotte.
Gelée au Maraschino.
Crême d'Ananas.

Petits Fours. Biscuits Parisien.

Chocolats, Caramels.

Glace aux Fraises.
Glace à la Vanille.
Café Glacé.

Café Noir et à la Crême.
Limonade, Orangeade.

DESSERT.

Supper at a Charity Ball in 1924.

◁ The dining table at my parents' house in London.

UNTIL ABOUT 1910 the habit of giving dinner parties at smart restaurants or hotels was almost unheard of. People entertained in their own homes. My parents used to give many dinner parties and I can remember watching all the preparations.

On the dining table was a starched white damask cloth and in the centre a large silver-gilt bowl, usually filled with pink carnations and gypsophila. Round the bowl and festooned over the side of the table were always garlands of green smilax.

On dinner party nights, Mr Morris the butler was helped by the head housemaid to serve the meal.

In 1918 after the war (during which I remember perpetually feeling hungry) I began to enjoy being invited to dine at houses where I knew the food was good. It was usually a party before a debutante's coming-out ball or a dance in aid of charity. A particular house in Bryanston Square I remember well because it was there that I first saw a polished mahogany dining table.

At all dinner parties there were name cards and handwritten menus. In large country houses it was customary for the head gardener to discuss with the lady of the house what flowers she would like for the table and then he, not the butler, would arrange them. In the 1930s I was invited to a house-party given by Mrs Arthur James, who had been a great friend of King Edward VII, at her house near Rugby. We always gathered in the drawing-room before dinner, no drinks were served, and each man was told who his dinner partner would be for the evening. Arm in arm we would then troop into the dining-room.

In the late 1920s entertaining in restaurants and hotels gradually became fashionable as private staffs were being reduced in number. Most of the hotels and restaurants had orchestras for dancing; even the conservative Ritz, in the late 1930s, had a dance orchestra and sometimes a cabaret.

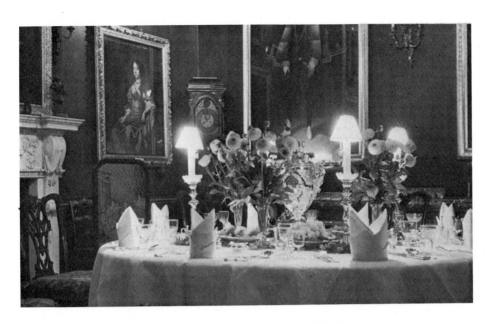

The dining table at Rufford Abbey, Lord Savile's home in
Nottinghamshire, in 1932.

Our dining-room at home.

Simpson's Fish Ordinary was the name of a special luncheon served at a small London restaurant near the Bank of England. Each day, if a customer could guess correctly the weight, height and girth of a giant cheese, the management gave all the customers free champagne. The building was destroyed by a bomb in 1941.

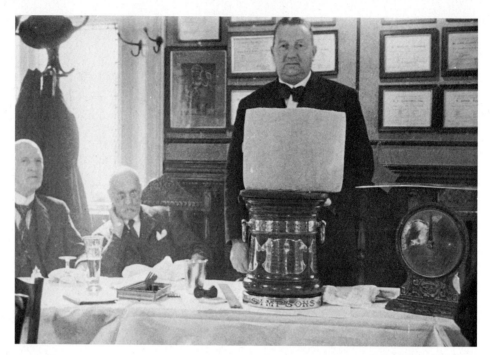

The restaurant at the Ritz Hotel in London, 1936.

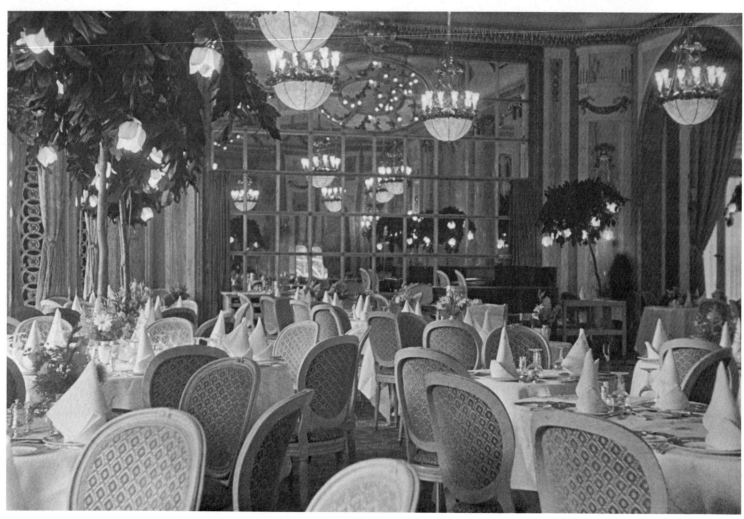

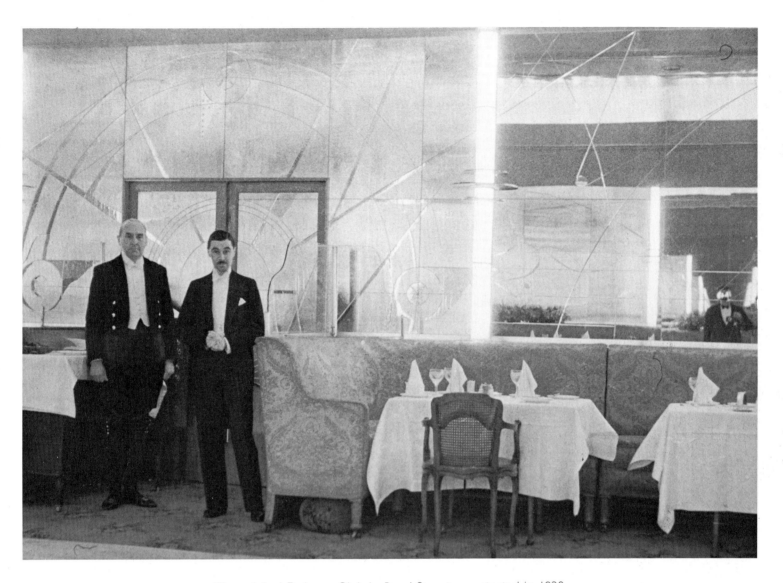

The original Embassy Club in Bond Street was started in 1920 by Luigi Naintre, an elegant and shrewd *maître d'hôtel*. Until it closed in 1938, the Embassy was probably the most exclusive and glamorous night club in the world. No press photographers were ever admitted; I, as one of the Club's original members, was allowed to take some pictures early one evening, with my new Leica, using a tripod. The pictures show the table, just inside the entrance door, always reserved for the then Prince of Wales. Men wore white tie and tails, and the women were in ball gowns designed mostly by Chanel, Molyneux, Hartnell and Stiebel. Bert Ambrose and then Jack Harris played wonderful dance music, soft but full of pep and non-stop.

THE COTTON CLUB

presents

ETHEL WATERS
GEO. DEWEY WASHINGTON

in

DAN HEALY'S

"COTTON CLUB PARADE"

(22nd EDITION)

WITH

DUKE ELLINGTON
and his FAMOUS ORCHESTRA

AND

FIFTY OF THE WORLD'S GREATEST SEPIAN ARTISTS

LYRICS AND MUSIC BY TED KOEHLER and HAROLD ARLEN

DANCES BY ELIDA WEBB and LEONARD HARPER
COSTUMES EXECUTED BY GENE
COSTUMES DESIGNED BY ERNEST SCHRAP
SHOES BY BEN & SALLY
ORCHESTRATIONS BY RUSSELL WOODING & "DUKE"
MUSIC PUBLISHED BY MILLS MUSIC, INC.

OVERTURE		DUKE ELLINGTON AND ORCHESTRA
Scene 1.	HARLEM HOSPITAL	
	Head Nurse	Sally Goodings
	Dr. Jones	Dusty Fletcher
	Doctor's Assistant	Cora La Redd
	Mr. Cotton Club	George Dewey Washington
		Nurses, Internes, Etc.
Scene 2.	SONG—"CALICO DAYS"	George Dewey Washington
Scene 3.	SOMEWHERE IN MISSISSIPPI	The Talbert Choir, Fayard Nicholas, Four Flash Devils, Cora La Redd, and Girls
Scene 4.	SNAKE HIPS	Josie Oliver
Scene 5.	ON LENOX AVENUE	Dusty Fletcher—"Ham Tree" Harrington
Scene 6.	THE HARLEM SPIRIT SONG—"HAPPY AS THE DAY IS LONG"	Henry "Rubber Legs" Williams
Scene 7.	GIRLS WILL BE BOYS	Cora La Redd, Harold Nicholas, Katherine Smith and Girls

In America

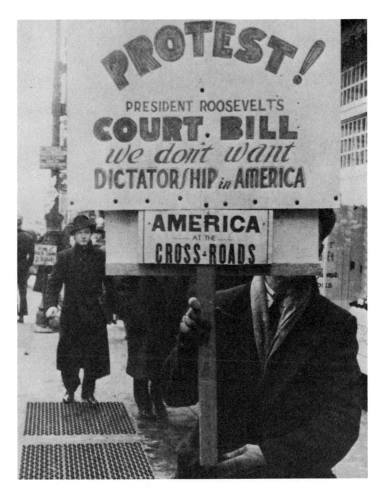

Lexington Avenue, New York, 1937.

◁ The Cotton Club programme with Ethel Waters and Duke Ellington in New York.

I HAVE BEEN an Americophile since 1922, when my parents took me on a world tour, prior to my starting work in a London shipping office. I was instantly thrilled by New York, the great friendliness of American people, the air of 'get up and go', and of course Broadway.

It was the year of Jeanne Eagels in *Rain*; of Gilda Gray, who danced the 'Shimmy Shake', and Gallagher and Shean in the *Ziegfeld Follies*; and of Paul Whiteman's orchestra in George White's *Scandals*.

When we sailed home on the *Aquitania*, I vowed to myself that I would return to America, and I have been returning for the past fifty-six years.

Fourteen years after my first visit, by which time I had written several successful travel books, I was told while staying in New York that Colston Leigh, a famous lecture agent was interested in booking people who could talk on travel. An appointment was duly made for me to see Mr Leigh who, after intensive questioning, decided that, although not a celebrity, I had 'got something' his public might like. Then came the task of outlining four lectures. It was decided that they would be entitled *Ancestral Homes and Gardens of England*, *The London Scene*, *Tickets Please* and *With a Passport and Two Eyes*, the last two being the names of my books, which covered India, Australia, Sudan, Egypt, Israel (then Palestine) and Hong Kong. Each lecture was to be illustrated by sixty stereopticon slides, all made from my photographs.

When I went to sign the contract I received a shock, for it was stipulated that the slides must be in colour. I refused, saying that to have them all coloured by hand would cost a fortune, but Mr Leigh insisted that unless the slides were coloured the deal was off.

Having got so far I eventually agreed. He then asked if, before I left for England in two days' time, I would write a synopsis of each lecture and supply his office with a dozen photographs to illustrate a brochure for organizations that booked lecturers for the following winter season. The problem of pictures seemed insurmountable till I remembered that I had brought with me some of my photographs to show friends in America. It was sad defacing my albums but it saved the day.

On returning to England I wondered if I had been rash, since I had no experience of lecturing to large audiences; but my great keenness to travel in America sustained me. A few months later I received a copy of the brochure, and apart from one rather embarrassing page headed 'Purely Biographical' it was all excellent.

Early in 1936, before going to stay with John and Lily McCormack near Dublin, I began searching through hundreds of negatives which would have to be made into 300 glass slides, each coloured by hand. I eventually discovered that the photographic department at Harrods, just round the corner from where we lived, offered me the cheapest lump-sum price (if I remember correctly, it came to only £40). Every negative had to be placed into a separate envelope with the exact colourings noted on the outside. The photographs ranged from desert scenes in the Sudan to an Indian Maharajah's palace, to a London street or a rock-garden belonging to some country mansion in Devonshire.

Although I never met the man who coloured the slides until he had finished the job, he had made only two mistakes. In a photograph of the library of an ancestral home, he did the book bindings in bright colours instead of dull browns. In the second case he gave a London policeman's uniform a greenish tint, when it should have been dark blue.

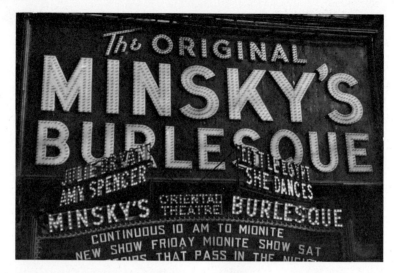

Minsky's Burlesque Theatre
in New York, 1933.

Fifth Avenue
Christmas shopping.

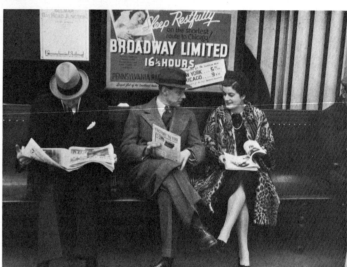

Waiting at Pennsylvania
Station for the Chicago train.
The *Broadway Limited* was the
crack train of the
Pennsylvania Railroad,
corresponding to the New
York Central's *Twentieth
Century*.

A view of the spires of St
Patrick's Cathedral from my
bedroom window at the
New Weston Hotel, on the
corner of Madison Avenue
and 50th Street.

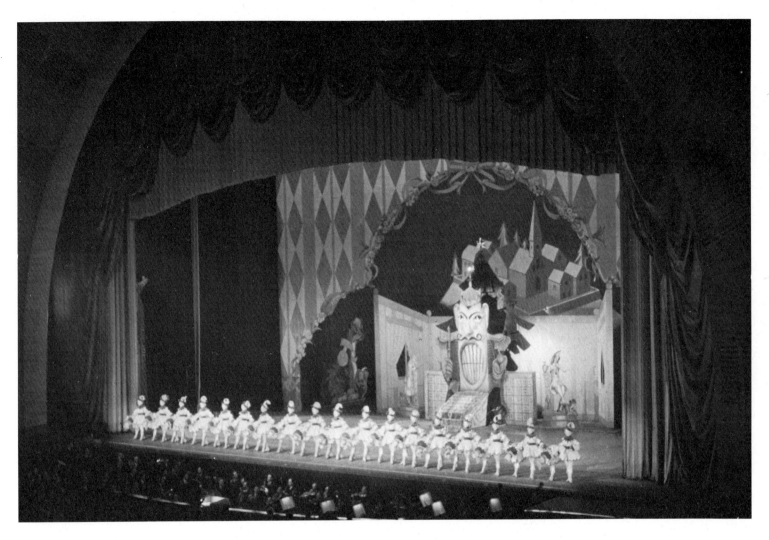

The stage of Radio City Music Hall, showing the Rockettes,
all eighteen of them dancing one of their precision numbers. I
took this picture as a time-exposure with my new Leica
(in 1934).

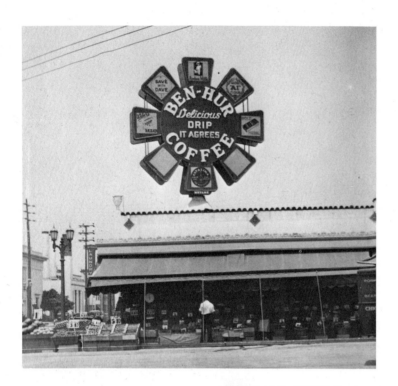

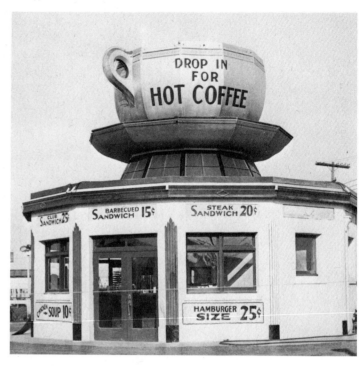

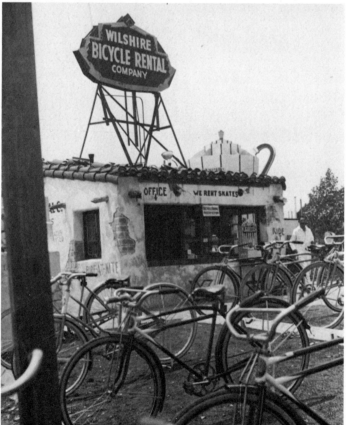

American shop signs were sometimes imaginative but rarely discreet. I was also taken by the way a small town with an Indian name, Wauwatosa, called itself a 'city of homes'. The reference to 'restrictive zoning' meant that the people who ran Wauwatosa frowned on the kind of eatery that advertised like those above.

Bicycles (and roller skates) for rent in Los Angeles.

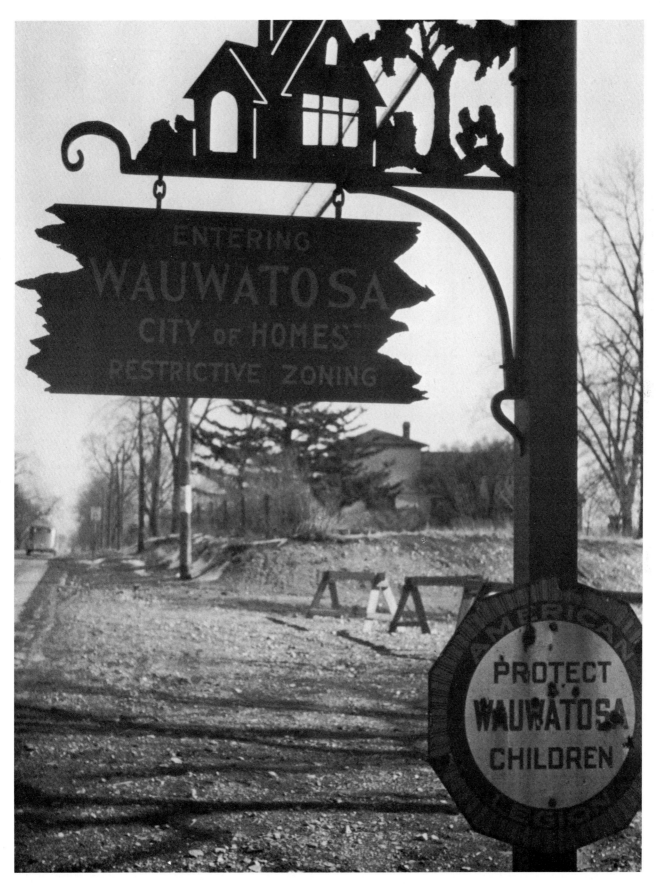

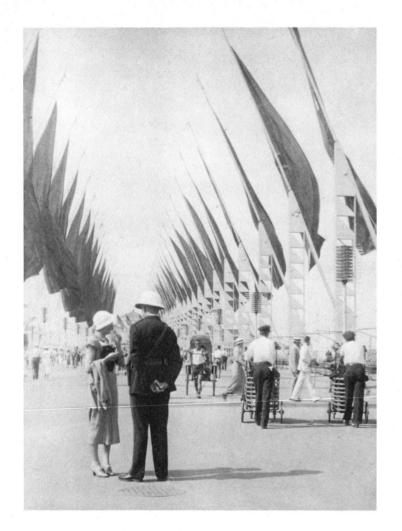

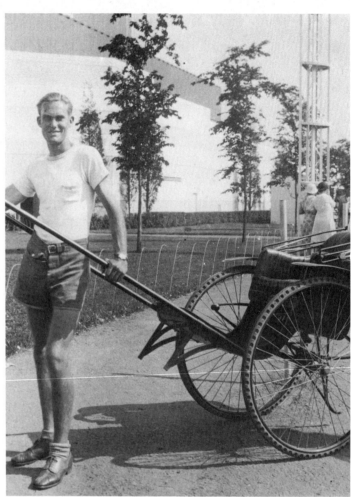

Scenes from the Century of Progress World's Fair held in Chicago in 1931. In that year of Depression, college boys acted as rickshaw runners to earn the odd dollar from elderly and tired sightseers.

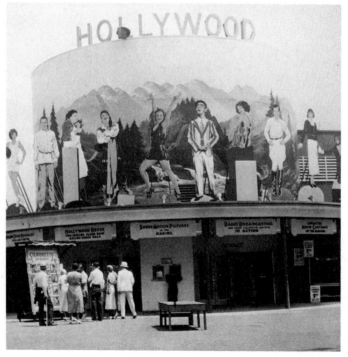

Hollywood

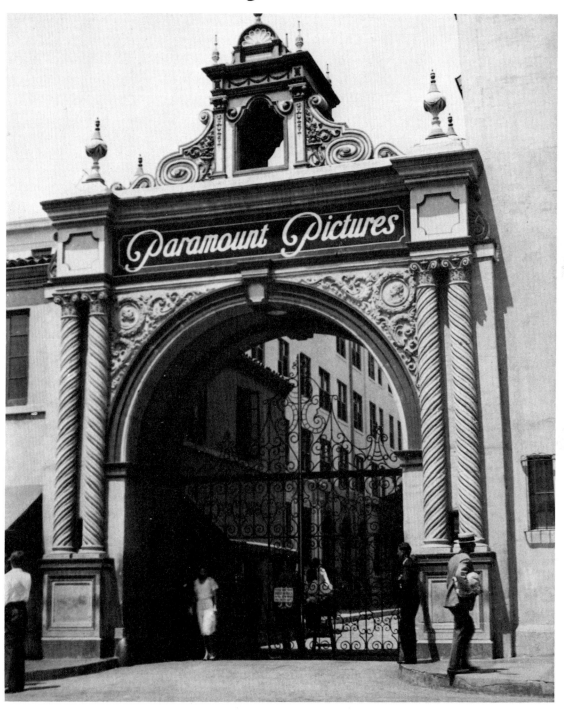

Without a pass, it was impossible to get through the entrance
gates of any Hollywood studio.

EVER SINCE my first visit to Hollywood in 1931, then at the peak of its most glamorous era, I was determined to return there. After the success of a travel book I wrote and illustrated with my photographs, I started to investigate the cheapest way to get to Hollywood and stay there for at least six months.

I soon found that a single ticket on the 10,000-ton Holland-America cargo liner *Delfdyk* was only £60. Each of the twenty passengers had a private cabin and the pleasant journey, via Bermuda, Curaçao, Puerto Colombia, and through the Panama Canal to Los Angeles, took 26 days. On arrival I was lucky enough to be made a temporary member of the Hollywood Athletic Club situated on Sunset Boulevard. For a very modest sum I had a room and bath, and the use of the swimming pool, gymnasium, sun-bathing roof, restaurant, barber shop and shoe-shine parlour. The latter two were the places where many of the current young male film stars met and gossipped most mornings. For transport I rented a Ford V-8 roadster for £5 a week, which included free oil, washing and garaging.

With a commission from the London *Sunday Chronicle* to write a weekly 'Hollywood Letter', I was welcomed into all the studios but only in rare cases with my camera.

At parties and among friends my Kodak was in constant use, and everyone seemed to like being snapped. I use the word 'snapped', because my photography since 1911 has been that of an enthusiastic amateur, but perhaps with a professional's eye for a good picture.

In the Twentieth Century-Fox studios: I am standing beside a wood-and-plaster replica of Trafalgar Square made for the filming of Noël Coward's play *Cavalcade* (1933).

Bramwell Fletcher and Heather Angel, two of the strong British contingent in Hollywood at that time.

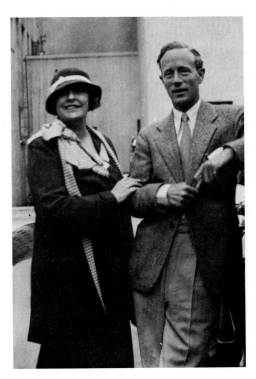

The matinee idol Leslie Howard, with his rarely photographed wife.

Richard Greene, the British actor, aboard the S.S. *Aquitania* on his way to take up a Twentieth Century-Fox contract in Hollywood.

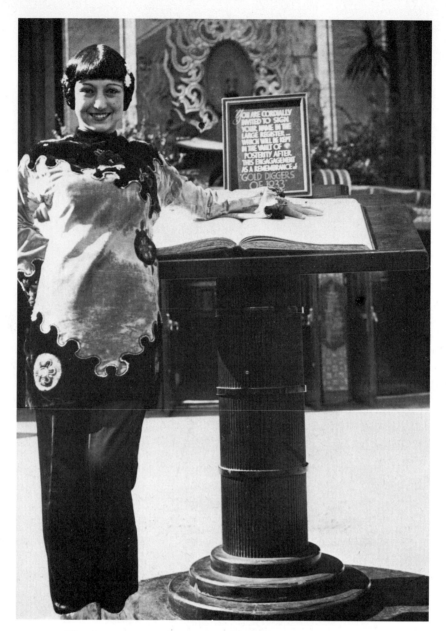

The forecourt of Grauman's Chinese Theatre, the movie
house in Hollywood where celebrities were invited to leave
their hand- and footprints in blocks of cement. The
usherettes naturally wore Chinese costumes as uniforms.

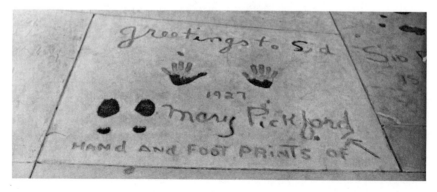

Johnny 'Tarzan' Weissmuller
on the sunbathing roof of the
Hollywood Athletic Club.

Cary Grant being photo-
graphed by fans on the beach
at Santa Monica.

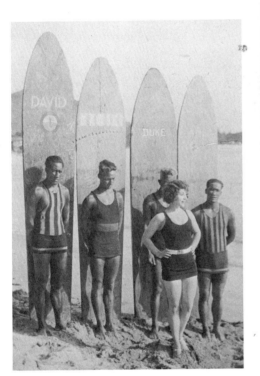

Betty Compson was a star of
the silent screen. Here she is
on the beach at Waikiki in
1922, making the film *The
White Flower*. Her co-star was
Edmund Lowe.

Joan Blondell posed with me
at the Warner Brothers
studios during the making of
Footlight Parade.

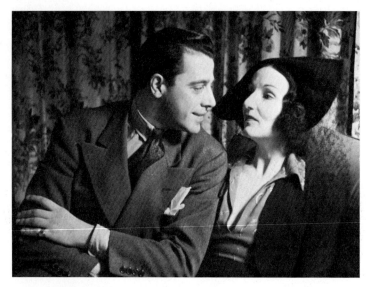

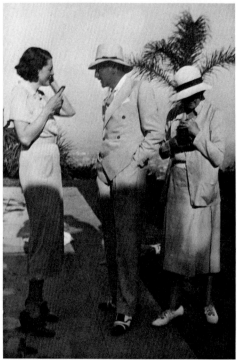

June, the lovely dancer and actress who first took London by storm in the 1920s entertaining at the Embassy Club. She married Lord Inverclyde and Mr E. Hillman, an American. With him she lived in California, and I took this picture of her at the Santa Anita race track in 1936.

Jack Larue, the movie star famous for his portrayals of gangsters, with his then wife Connie in 1938.

Irene Browne, the British actress, Adolphe Menjou and Lily McCormack at a Hollywood party.

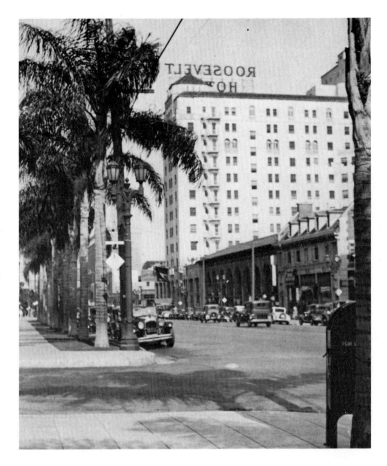

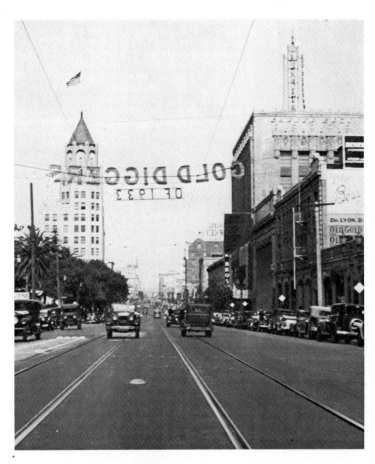

The Roosevelt Hotel in
Hollywood.

The banner stretched across
the Los Angeles street is
advertising the famous
Warner Brothers musical,
Gold Diggers of 1933.

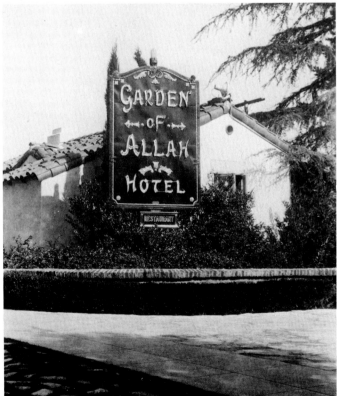

The Garden of Allah was a
famous bungalow apartment
hotel on Sunset Boulevard,
frequented by the rich and
famous movie stars. This is
also where F. Scott Fitzgerald
spent the last years of his
life.

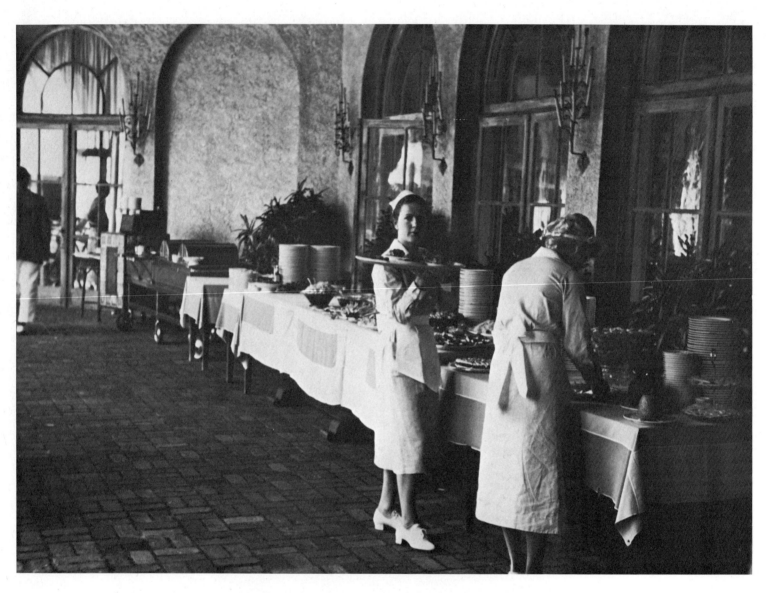

Palm Beach, Florida, 1934: a buffet lunch at the Surf and
Sand Club.

The lobby of the venerable Brown Palace Hotel in Denver, Colorado, where I stayed on my coast-to-coast lecture tour in 1937.

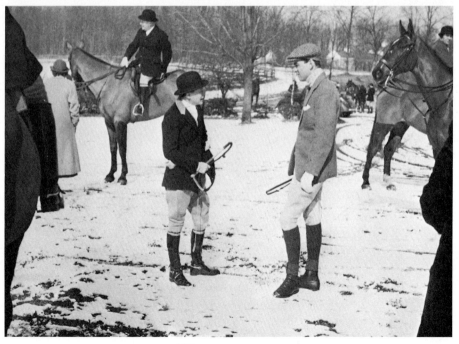

The meet of the Essex Fox Hounds at Middlebrook, Far Hills, New Jersey, in 1937.

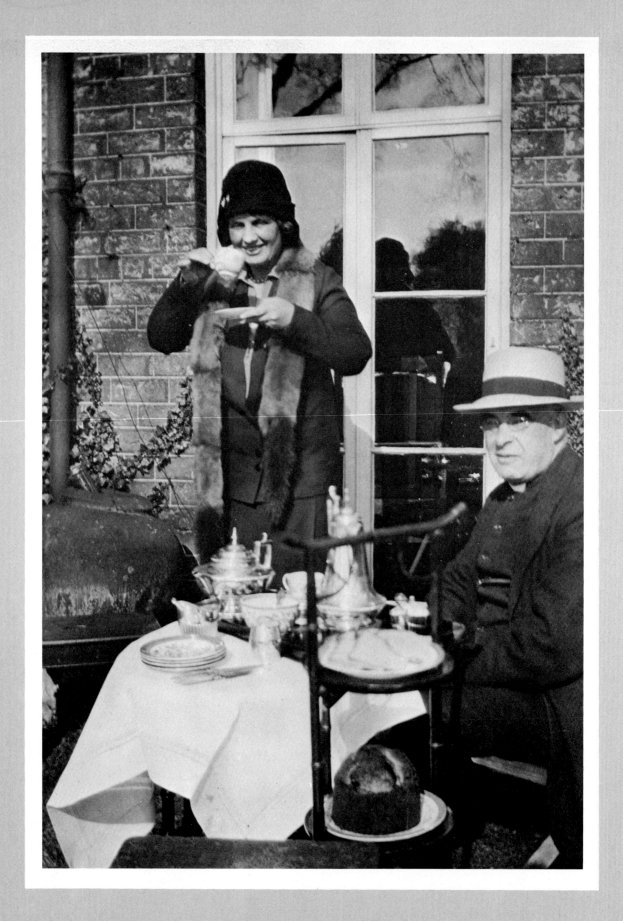

At Home

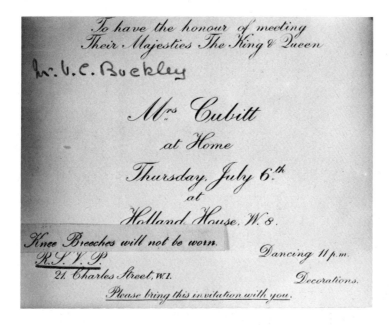

To have the honour of meeting
Their Majesties The King & Queen

Mr V. C. Buckley

Mrs Cubitt
at Home
Thursday, July 6th
at
Holland House, W.8.

Knee Breeches will not be worn.
R.S.V.P Dancing 11 p.m.
21. Charles Street, W.1. Decorations.
Please bring this invitation with you.

An invitation to the last great ball to be held in London
before the outbreak of war in 1939.

◁ Afternoon tea in the garden with home-made cakes and cucumber sandwiches.

IN JULY 1939 I went to the last function ever to be held in Holland House, that historic Elizabethan mansion that stood in several acres of parkland, a stone's-throw from London's Kensington High Street. Lord and Lady Ilchester had lent the house to Mrs Cubitt for her daughter's coming-out ball. The London social season was almost over and there was a feeling of strained gaiety, as if people were saying, 'This may be the last for some time, let's crowd in as much for the young as possible'. (Just over a month later, Hitler's troops invaded Poland.)

I have a vivid memory of that evening. The long elm-bordered avenue was packed with sleek motor cars, so that it took an hour to traverse a few hundred yards. When I finally entered the stately white-and-gold ballroom it was midnight. The orchestra had just stopped playing and the King and Queen, about to go down to supper, were standing in the middle of the room talking to Noël Coward. This was a gathering of three generations, for the owners of Holland House had invited their friends of the Edwardian era, there were also young marrieds, and then the debutantes.

Even against the background of superb paintings and chandeliers the Queen commanded all attention. I had never seen her so close-to or looking more radiant. She wore a white crinoline-type ball gown, designed by Norman Hartnell, and a diamond-and-ruby tiara and necklace. Queen Ena of Spain, also a guest, was wearing white with ropes and ropes of enormous pearls reaching to her waist. As a scene it was very exciting—I imagine almost as dazzling as a ball at Buckingham Palace.

Unfortunately, it was a pouring wet night, so no one ventured onto the flood-lit terraces which overlooked the formal Italian garden with its massive clipped yew hedges. This was a real country house in the very heart of London.

As the strains of a waltz floated into the library, I suddenly thought: This is like the Duchess of Richmond's famous ball on the eve of the Battle of Waterloo. Once when the orchestra was playing 'These Foolish Things,' I heard a young girl say to her partner, 'What exactly is the Polish Corridor?'

As I stood in the hall about to leave, the King and Queen came down the great oak staircase. The Queen paused a moment to speak to her godmother Mrs Arthur James and then slowly continued talking to her hosts. Guests near the door curtseyed low and I heard the King say, 'We have enjoyed the party so much. Look it's nearly two!'

Later as I walked down the avenue of tall trees and out into the street I heard a clock strike. It was striking the death-knell of another era, just as it had done a quarter of a century before. The next time I saw Holland House the inside was a smouldering ruin from a direct hit by a bomb.

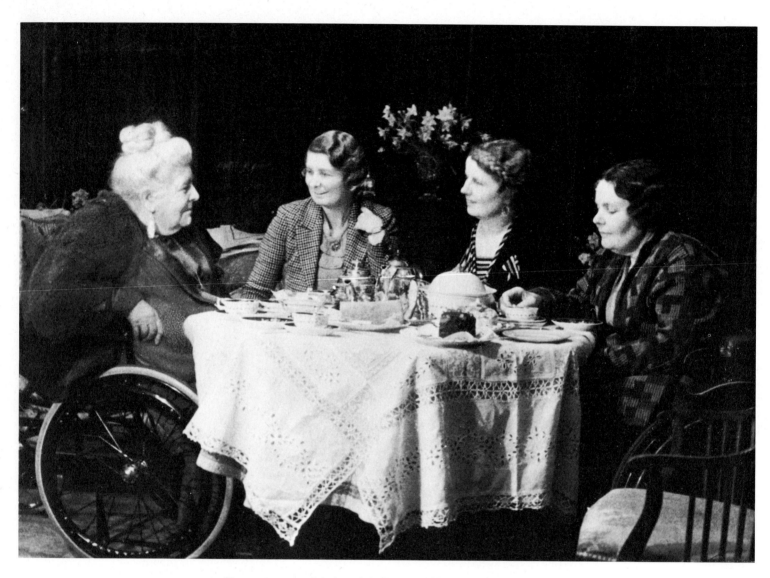

Tea at my cousin's London flat in 1930. Mrs Gwendoline
Yates and her three daughters Vera, Gertie, and Millie.

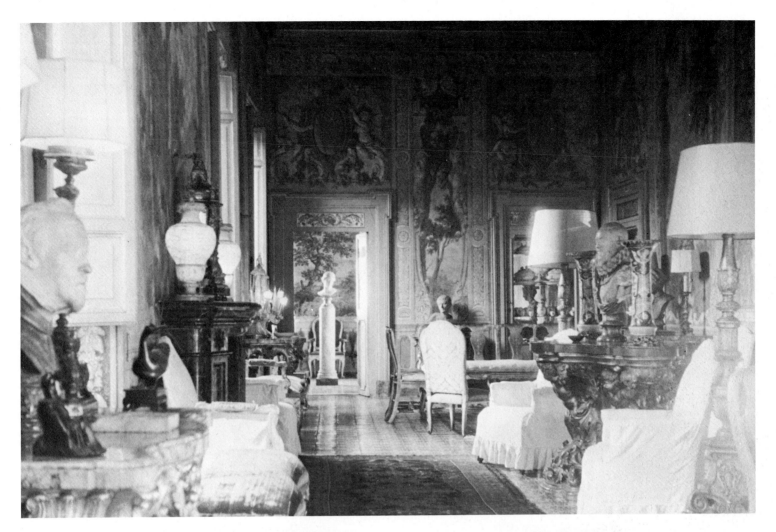

The ballroom in the Palazzo Sermoneta, Monte Savello, Rome. The Palazzo was built on the site of the Roman theatre of Marcellus.

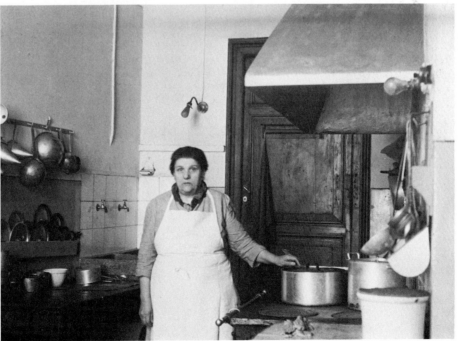

The cook in the kitchen of the Palazzo. Dinner parties usually started at 10 p.m.

146 Piccadilly (now demolished to make way for the road
that leads from Park Lane to Piccadilly) was the London home
of Anna Lady Newman. Next to it was a house which
belonged to the Rothschilds, which in turn was next to the
Duke of Wellington's, affectionately known as 'Number One,
London'.

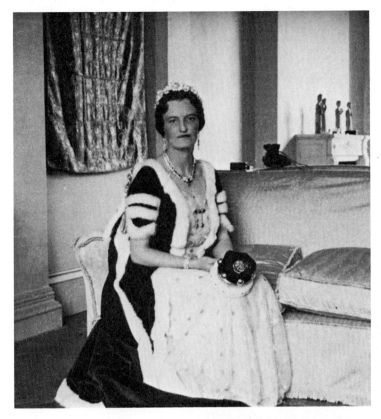

Baroness Ravensdale, eldest daughter of Viscount Curzon of Keddleston, Viceroy of India in 1898. Her mother, Mary, the beautiful and clever daughter of the millionaire Leiters of Chicago, had captivated English society. Irene Ravensdale inherited her mother's beauty and her father's brains. In this picture, which she asked me to take, she is wearing her peeress's robes for the Coronation of King George VI in 1937.

A lady's boudoir, 1915 style. Note the art-nouveau cushions, 'tango' shoes, and the black upright telephone on the table.

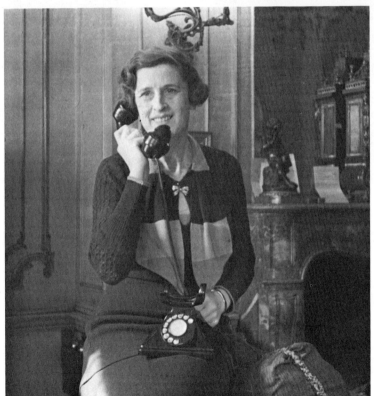

Zena Dare, musical comedy star in the early part of the century, was one of the most charming and most photographed beauties of that era. After her marriage to Lord Esher's son, Maurice Brett, she retired from the stage and had three children. From 1926 on, she resumed appearances on the stage and her last engagement was as Mrs Higgins in the London production of *My Fair Lady*.

Drawing-room in a country
house. Strood Park, near
Horsham in Sussex, belonged
to my aunt and uncle.

A bridge party in our
London home.

In order to have peace while writing a book I went to stay with friends of my parents, a vicar and his wife who lived in a village rectory near Lincoln. It was indeed remote: the house had no electricity, no telephone, no radio. Two maids helped to run the house. The food was dreary, there was no running water in the bedrooms; they did not take a daily paper—but they were kindly people.

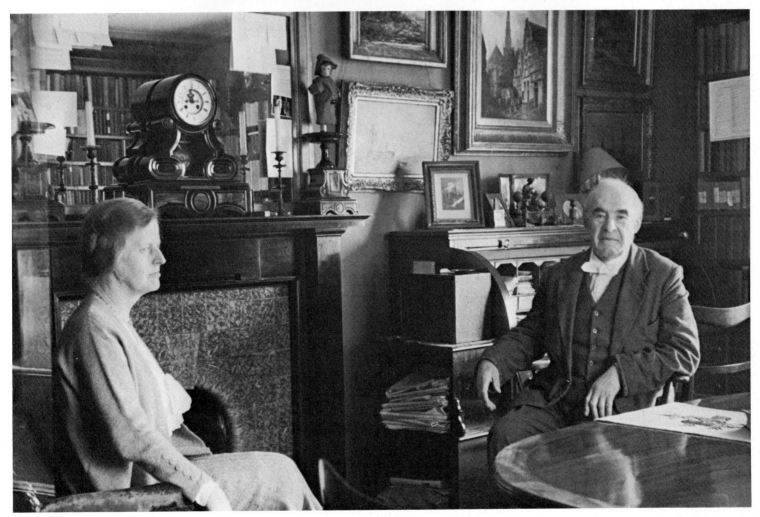

Kyra Nijinsky, daughter of the famous Russian dancer. A
young ballerina herself, she stayed with a friend of my
parents in London in 1934 while she prepared to appear in a
C. B. Cochran revue.

◁ The great Irish tenor, John McCormack.

EVER SINCE I was at school I have envied and admired people in the world of theatre. At the age of 16 I started to write to stars asking for a signed picture post-card. One of the first to answer was Elsie Janis, an enchanting American who, in 1917, starred in the revue *Hello America* at the Palace Theatre.

Encouraged by her reply, I called one day at the theatre to present her with some flowers. I was duly shown up to the dressing room but was met at the door by her formidable mother who said, 'Elsie is rather tired and I'm afraid can't see you.' With that, she propelled me across the corridor into a room, saying, 'This is Elsie's new leading man, have a chat with him.'

The man seemed surprised but asked me to sit down and, with a strong foreign accent, said, 'Yes, I 'ave only been 'ere a week. My name is Maurice Chevalier.' At the time his name meant nothing to me and I was furious at not being allowed to see lovely Elsie.

Considering I have had nothing to do with the stage, I have been fortunate enough over the years to make many good friends in the theatrical world and later in Hollywood. Perhaps they have valued a non-professional's enthusiasm. I have often been asked to give my opinion on a song or a scene.

My mother was a friend of Dame Nellie Melba, that great Australian prima donna, who once said to her, 'In life, if you want to know something, always go the expert on that subject. As for me, the Rothschilds handle my finances, Madame Lucille designs my clothes and I employ London's best interior decorator for my house.' I suppose one might add that God gave her that wonderful voice.

A wedding party at Croydon Aerodrome seeing off the bride
and bridegroom on a Paris honeymoon (1934).

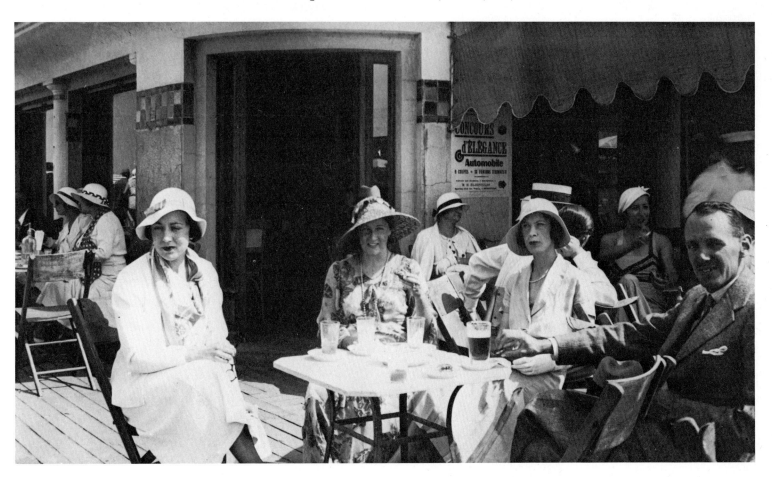

Pourville, a resort on the Normandy coast, was popular with
the British in the 1920s.

Jock Lawrence, a public relations expert, was one of Samuel Goldwyn's right-hand men in the 1930s. During the war he was on General Eisenhower's staff and later on that of SHAPE in Paris.

The beautiful Mrs Charles Sweeney (now Margaret, Duchess of Argyll) photographed in 1935 at her home in London.

The Maharajah of Rajpipla and friend at his home near Windsor.

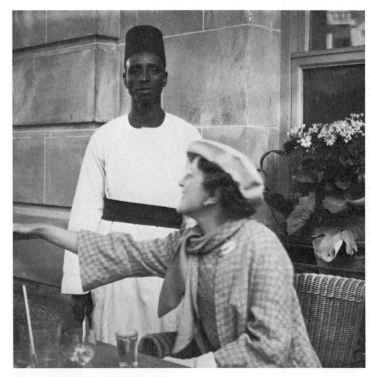

The Duchess of Sermoneta, one of Europe's greatest beauties in the early 1900s. She was born a Colonna, one of Rome's most illustrious families, and her full title was 'Donna Vittoria Caetani duchesa de Sermoneta'.

Mrs Woolley-Hart, an American international hostess, outside Shepheards Hotel in Cairo, offering her elegant hand to an unseen gentleman.

Barbara Cartland, the beautiful and talented authoress of successful romantic novels, seen here in 1936 in her Mayfair flat, London.

Sylvia Grey, a celebrated dancer at the Gaiety Theatre at the
turn of the century. On a visit with her to the new Gaiety
Theatre in the Strand in the 1930s, I photographed her with
some of the usherettes and bar attendants. She told us that
when, in the old days, she made her first entrance, the
spotlight operator would call out: 'What sort of spotlight do
you want, Miss Grey?' She would always reply, 'A silvery *grey*
one, of course!' This got a laugh from the audience before
she glided into her dance, hardly ever lifting her dress above
her knees.

Major Berkeley Levett at his Devonshire home in 1929. In 1890, as a subaltern in the Scots Guards, he was one of the members of a house-party at Tranby Croft in Yorkshire, where he witnessed Sir William Gordon Cumming cheating one evening at baccarat, a card game usually played only in casinos. Since the Prince of Wales was a member of the company, the court case that ensued, after an action for slander brought by Sir William, became the biggest society scandal of the late Victorian era.

Fredric March and his wife Florence Eldridge, those talented and much-loved film and stage stars, at Hampton Court during their first visit to England, 1934.

John Drinkwater (left), poet and author whose play *Abraham Lincoln* was much acclaimed, meets John McCormack for the first time, on a tennis court in London.

Theda Bara (left), the silent film actress on a visit to London. When she first went to Hollywood in the early days, the studios wanted to change her name to something more exotic than her own name, Goodman, so they took the word Arab and spelt it backwards. It was her performance as Salome that gave birth to the word 'vamp'.

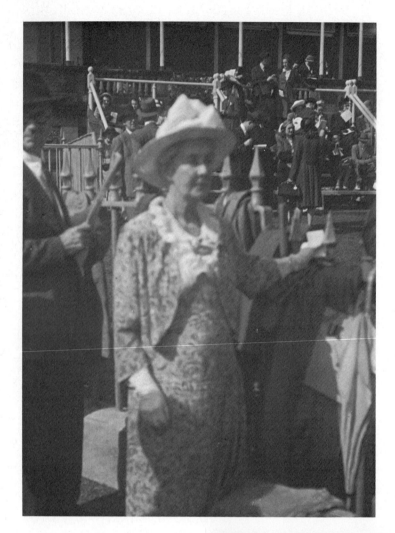

Mrs Helen Vernet, the only lady bookmaker who worked on the 'rails' in the 1930s. Elegant, efficient and charming, she graced the race meetings she attended in any kind of weather.

In the typists' room of the passenger office of the Blue Star Line in Lower Regent Street.

'Nan' was engaged by my parents as a child's nurse shortly after I was born in 1901, and died of a broken heart after she retired in 1945 and went to live with a sister. 'Nan, can you lend me five pounds?' 'Nan, will you help me dress—I'm in a hurry.' 'Nan, cook is ill—can you do the dinner?' She looked after us all, and we loved her dearly.

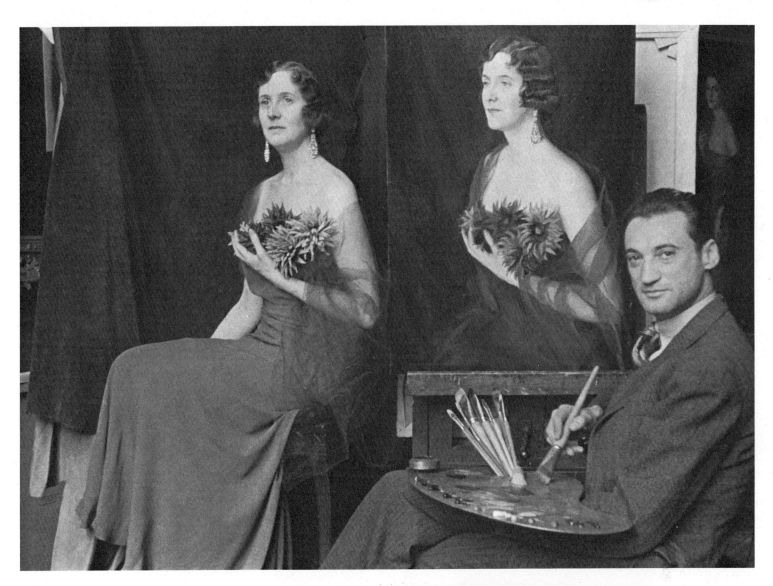

The artist Martin de Hodzu
painting a portrait of
Princess Pauline Melikoff.

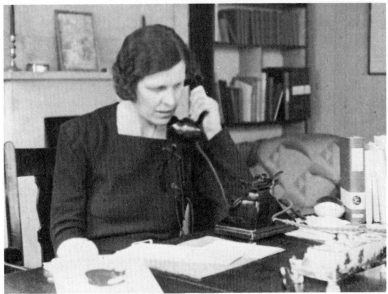

Mrs Bertine Hay, owner of
the Athenaeum Press in 1932,
was at that time the only
woman publisher in England,
and printed Stephen King-
Hall's influential News
Letter.

Grace Palotta, a musical-comedy actress from Vienna who, at
the turn of the century, took London by storm with a song,
'Oh Listen to the Band', which was sung, whistled and played
everywhere. I photographed her by the bandstand in Hyde
Park.

Madame Guy d'Hardelot was the composer of many ballads,
including the world-famous 'Because'.

Zo Elliott, American composer of the famous marching song of the First World War, 'There's a Long Long Trail'. While at Yale, he composed the music to the lyrics written by a fellow-student, Stoddard King. While Elliott was at Cambridge University in 1915, Canadian troops suddenly started to use his tune, and from then on it was an all-time success.

ON 30 AUGUST 1939 I telephoned my parents in London and insisted that they leave at once and come to my cottage at Wickhamford, near Stratford-on-Avon in Worcestershire. They duly arrived with our faithful old Nanny West, my Corgi dog, mountains of luggage—and their gas-masks.

After dinner that evening I announced that I was leaving next morning, as I did not like the possibility of dear London being bombed while I was safely ensconced in the countryside. Everyone thought I was going to my doom and that London would soon be a smoking ruin. My mother was tearful, my father said, 'I trust that with your world-wide travel experiences you will get army intelligence work', and the lady from the Manor begged me to find her son Jim, who was already on Air Raid Precautions duty.

As I stood at the front door I looked back through the latticed windows into the little garden and thought of Thomas Moore's words,

> *The memory of the past will stay*
> *And half our joys renew.*

It was the last time I ever looked through those windows. At the top of Fish Hill I saw the lovely Vale of Evesham, and at Uxbridge I suddenly noticed lots of black dots in the sky—London's protective balloon-barrage. At Northolt Aerodrome, fighter planes were lined up in front of hangars.

Few who were in London on the night of 2 September 1939 will ever forget it. When darkness came, an unbelievably inky blackness enveloped the city. Later a most violent thunderstorm broke, the vivid lightning stabbing the silent city. As a terrific peal of thunder rent the air, it seemed like God's angry voice telling us mortals of his displeasure.

The lightning illuminated some military lorries that had crept into our street and were parked in rows. I wondered why they should be in this secluded area. Then I remembered that the disused Brompton Road underground station, near Harrods, had been commandeered by the military, its use then shrouded in great secrecy.

As the storm rumbled away and all was deathly quiet, I recalled those famous words of 1914 of Sir Edward Grey, exactly a month before I went to school at Eton, 'The lights are going out all over Europe.'

Early next morning, I heard on my radio that the Prime Minister would speak to the nation at 11 o'clock. I dashed off later to the Chelsea Town Hall. There someone asked, 'What can you do?' I replied that I had a car and knew London as well as most taxi drivers. 'Fine—we want people with cars. Go to 96 Cheyne Walk and report for duty as an ARP driver.'

There was pandemonium in the courtyard of Hudson's Furniture Depository, where that wonderful actor Sir Lewis Casson was in charge. Our job would be to take stretcher-bearers to the scene of any bomb 'incident'. I had barely drawn my car into line when an agitated woman rushed across the street and said, 'The canteen manager wants someone to fetch twenty loaves of bread from Lyons' depot at Cadby Hall.' She pressed a piece of paper into my hand and vanished. Having collected the loaves, I turned on my car radio as it struck eleven and heard the Prime Minister say, 'We are now at war with Germany.'

Suddenly the stillness of that cloudless Sunday morning was shattered by the wail of the air raid sirens. It was the first time that I had heard them. As I drove, at 60 m.p.h., through the deserted streets I saw figures in doorways peering up at the sky. Just as I reached the ARP depot the 'all clear' sounded. It had been a false alarm.

Lewis Casson greeted me angrily: 'Where have you been, Buckley, suppose there had been a raid—you must never leave here without permission.' I mumbled something about twenty loaves and the canteen and realized I was now just one small cog in a vast, if not yet run-in, war machine.

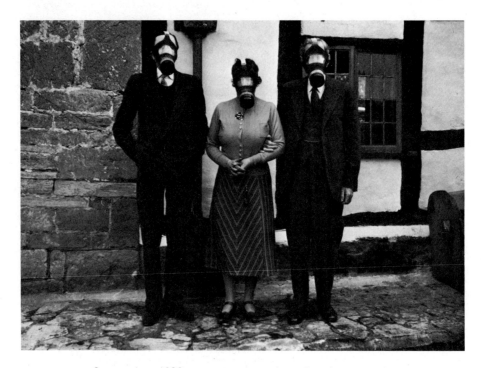

September 1939: my parents and my brother practise
wearing their gas-masks.